# Photoshop® CS3 Accelerated

Y.

# Photoshop® CS3  A c c e l e r a t e d

ISBN: 978-89-314-3437-8

Printed and bound in the Republic of Korea.

**How to contact us:**

support@youngjin.com

feedback@youngjin.com

Address: YoungJin.com

3F Mapo Tower Bldg, 418-1 Mapo-dong, Mapo-gu, Seoul 121-734, Korea

Fax: 82-2-2105-2206

**Credits**

Author: Blues Kim

Production Manager: Suzie Lee

Editorial Service: Publication Service, Inc.

Developmental Editor: Jonathan Harrison, Publication Service, Inc.

Editorial Manager: Lorie Donovan, Publication Service, Inc.

Book Designer: Design Chang

Cover Designer: Litmus

Production Control: Woong Ki, Sangjun Nam

# Photoshop® CS3

Accelerated

# Installing Photoshop CS3 > > >

Photoshop is a graphics program that, because of its many powerful functions, requires a system with relatively high capabilities. You can install Photoshop automatically using an original program CD. If you do not have the Photoshop CD, a try-out version can also be installed. The try-out version can be used for only 30 days and can be installed only once on a system.

**1** To install the program, insert the program CD in the CD-ROM drive. Installation automatically begins, and the CD checks the system. Click the Decline button in the lower part of the license agreement dialog box.

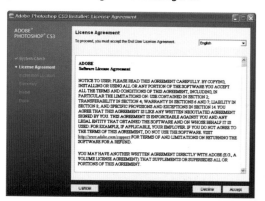

**2** Set the location where the program should be installed. To select a different installation location, click Browse.

**3** Check the installation location, and if the location is correct, click Install.

**4** The program automatically proceeds with installation.

**5** When installation is complete, start the program. When the program is executed, another dialog box appears asking whether you agree to the license agreement. Click Accept.

**6** Type in the program's product number, and click Next.

**7** Type in your personal information, including name, company name, and email address. The program is now running and ready for use.

Chapter | **1**

# This is Photoshop CS3

Welcome to the world of Photoshop. Photoshop CS3 is the latest version of this powerful software package, and you can use it to create images for both print and the Web. When you install Photoshop CS3, you'll also have access to ImageReady CS3, which is designed specifically for working with Web graphics. In the first chapter of this book, we'll learn some of the basic skills that you'll need to work effectively in Photoshop. We'll look at the Photoshop environment and discover how to use Photoshop's tools. We'll also cover color modes and file formats. By the end of this chapter, you'll have a foundation of knowledge that will prove invaluable as we introduce new skill sets in the coming chapters.

# Getting Started

**B**efore you start working with Photoshop, it is important to know some basic skills and familiarize yourself with the Photoshop interface. In this chapter, you will learn to use some of the rudimentary functions in Photoshop, including tools and palettes, by creating and saving an image.

## Photoshop CS3 Basics

Before you start working with Photoshop, it is important to understand the workspace and learn some basic skills. We'll begin by learning about the Photoshop interface.

### Exploring the Interface

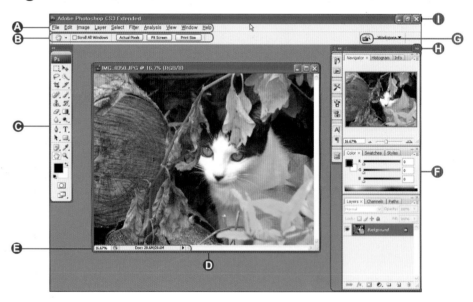

Ⓐ **Menu bar:** Photoshop contains nine menus: File, Edit, Image, Layer, Select, Filter, View, Window, and Help.

Ⓑ **Options bar:** The Options bar allows you to set options for the tool that you're currently using.

Ⓒ **Toolbox:** The Toolbox contains the tools that you'll use to work with images. It's important to learn how to use each tool.

Ⓓ **Active image area:** This window shows the current image. The window title bar includes the file name, view magnification, layer name, image mode, and bit depth.

**Ⓔ Status bar:** The Status bar shows the magnification of the image and its file size. You can open other images by clicking ▶.

**Ⓕ Palettes:** Palettes set options for tools and images. Related palettes appear together in the same group.

**Ⓖ Go to Bridge:** Open Adobe Bridge, which makes searching for photos easier.

**Ⓗ Expand Dock :** You can reduce or increase the size of the palette.

**Ⓘ Minimize, Maximize, Close:** These buttons minimize, maximize, and close Photoshop.

## Working with Tools

The Toolbox for Photoshop CS3, where the most frequently used tools are collected, appears in a tall vertical box when the program is first installed, which resolves the problem of shortage of screen space for users with small monitors.

However, in order to use the Toolbox in the classic shape as in the existing version, press the shortcut keys on the upper part of the Toolbox. By clicking the small triangle button ( ) in the lower right side of the Toolbox, you can see the hidden tools in a more detailed menu.

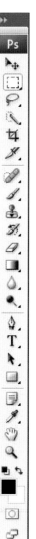
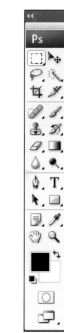

# The Toolbox

Let's look at the functions of all the tools in the Toolbox.

## Ⓐ Marquee Tools

- Rectangular Marquee Tool ( ): Makes a rectangular or square selection.
- Elliptical Marquee Tool ( ): Makes an elliptical or circular selection.
- Single Row Marquee Tool ( ): Makes a horizontal selection one pixel in height.
- Single Column Marquee Tool ( ): Makes a vertical selection one pixel in width.

**Ⓑ Move Tool ( )**

If you have made a selection, this tool will move the current selection. Also used for moving layers and guides.

**Ⓒ Lasso Tools**

- Lasso Tool ( ): Makes a selection by drawing freehand lines.

- Polygonal Lasso Tool ( ): Creates a polygonal selection by drawing connected straight lines.

- Magnetic Lasso Tool ( ): Automatically traces edges to select specific shapes within a graphic.

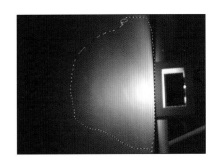

**Ⓓ Quick Selection Tools**

- Quick Selection Tool ( ): Select areas as if drawing with the Brush tool.

- Magic Wand Tool ( ): Selects areas having similar properties within a graphic.

**Ⓔ Crop Tool ( )**

Redefines the image area by highlighting the desired area then trimming away the remaining edges.

**Ⓕ Slice Tools**

- Slice Tool ( ): Slices an image into smaller portions.

- Slice Select Tool ( ): Selects or moves a slice.

## Ⓖ Correction Tools

- Spot Healing Brush Tool ( ): Corrects small imperfections in an image.

- Healing Brush Tool ( ): Removes imperfections by blending areas and matching texture, lighting, transparency, and shading.

- Patch Tool ( ): This tool is similar to the Healing Brush tool. It allows you to choose a patch to cover imperfections.

- Red Eye Tool ( ): Removes red-eye from photos for which a flash was used. It also removes light reflections from eyes.

## Ⓗ Painting Tools

- Brush Tool ( ): Adds brush strokes to an image using the foreground color.

- Pencil Tool ( ): Paints hardedged lines using the foreground color.

- Color Replacement Tool ( ): Changes a selected color to a new color.

## Ⓘ Clone Tools

- Clone Stamp Tool ( ): Clones one area of an image to another area.

- Pattern Stamp Tool ( ): Stamps a selectable graphic pattern on the image.

## Ⓙ History Brush Tools

- History Brush Tool ( ): Paints from a snapshot or earlier version of the image.

- Art History Brush Tool ( ): This tool is similar to the History Brush tool but it uses artistic brush strokes.

## Ⓚ Eraser Tools

- Eraser Tool ( 🖉 ): Erases from the image. In the background layer, the tool erases to the background color. In other layers, the tool erases to a transparent background.

- Background Eraser Tool ( 🖉 ): Erases the background color from a layer without affecting the foreground. You need to enter values for the Sampling, Limits, and Tolerance settings in the Options bar.

- Magic Eraser Tool ( 🖉 ): Erases colors similar to the clicked color. The settings in the Options bar willdetermine what is erased.

## Ⓛ Fill Tools

- Gradient Tool ( ▭ ): Fills using a color gradient.

- Paint Bucket Tool ( 🖉 ): Fills with the foreground color or pattern.

## Ⓜ Sharpness Tools

- Blur Tool ( 🖉 ): Blurs the image.

- Sharpen Tool ( 🔺 ): Sharpens the edges within an image.

- Smudge Tool ( 🖉 ): Smudges an image as if it has been rubbed by a finger.

## Ⓝ Brightness and Saturation Tools

- Dodge Tool ( 🖉 ): Lightens part of an image.
- Burn Tool ( 🖉 ): Darkens part of an image.
- Sponge Tool ( 🖉 ): Increases or decreases the color saturation of part of an image.

## ⓞ Path Tools

- Pen Tool (  ): Draws paths by creating anchor points.

- Freeform Pen Tool (  ): Draws freeform paths.

- Add Anchor Point Tool (  ): Adds anchor points to a path.

- Delete Anchor Point Tool (  ): Deletes anchor points from a path.

- Convert Point Tool (  ): Edits points on a path.

## ⓟ Type Tools

- Horizontal Type Tool ( T ): Adds horizontal text.

- Vertical Type Tool ( IT ): Adds vertical text.

- Horizontal Type Mask Tool(  ): Adds a horizontal selection in the shape of the text.

- Vertical Type Mask Tool (  ): Adds a vertical selection in the shape of the text.

## ⓠ Path Selection Tools

- Path Selection Tool (  ): Selects paths.

- Direct Selection Tool (  ): Selects parts of paths for modification.

## ⓡ Shape Tools

- Rectangle Tool (  ): Draws rectangular and square shapes.

- Rounded Rectangle Tool (  ): Draws rectangular and square shapes with rounded corners.

- Ellipse Tool (  ): Draws elliptical and circular shapes.

- Polygon Tool (  ): Draws polygons and stars.

- Line Tool (  ): Draws lines and arrows.

- Custom Shape Tool (  ): Draws custom shapes according to the selection in the Options bar.

### Ⓢ Notes Tools

- Notes Tool (🗐): Adds text notes to an image

- Audio Annotation Tool (🔊): Adds audio notes to an image.

### Ⓣ Sampling and Measuring Tools

- Eyedropper Tool (🖊): Samples a color to use as the foreground color.

- Color Sampler Tool (🖊): Samples up to four clicked colors.

- Measure Tool (📏): Measures distance, location, and angles.

- Count Tool(¹2³): You can select tools and input numbers when clicking on each image. The input number can be deleted on the option bar or by clicking while Alt is pressed.

### Ⓤ Hand Tools (✋)

Used when you can't see the entire image in the image window. Drag with this tool to move the portion of the image that's shown in the window.

### Ⓥ Zoom Tools (🔍)

Zooms in and out of an image. Zoom out by holding down the Alt key.

### Ⓦ Set Foreground Color (■)

Shows the current foreground color. Click the swatch to choose a new foreground color. Use the Alt-Delete shortcut to fill the image with the foreground color.

### ⊗ Set Background Color (▣)

Shows the current background color. Click the swatch to choose a new background color. Use Ctrl-Delete to fill the image with the background color.

### ⊙ Switch Foreground and Background Colors (↰)

Click to swap the foreground and background colors.

### ❷ Default Foreground and Background Colors (▣)

Click to revert to the default colors---the foreground color becomes black while the background color is set to white.

### ⒜ Edit in Quick Mask Mode (▣)

Select an area with the quick mask. By clicking once more, the mode returns to the standard mode.

### ⒝ Change Screen Mode (▣)

Set the four types of screen editing mode: Standard Screen Mode, Maximized Screen Mode, Full Screen Mode with Menu Bar, and Full Screen Mode.

- Standard Screen Mode (▣): The standard view showing the Menu bar, Toolbox, and palettes.

- Maximized Screen Mode (▣): Magnify the working area of the image, leaving the toolbox, palette, and menu bar as they are.

- Full Screen Mode with Menu Bar (▣): This view fills the screen with the image window. The Menu bar is retained but the image window's title bar is not.

- Full Screen Mode (▣): This view fills the screen with the image window. The area surrounding the image window is filled with black, and both the Menu bar and title bar are removed.

tip >>

**Shortcuts for Tools**

As you mouse-over tools in the Toolbox, the shortcut key for each tool is shown to the right of the tool name.

## The Palettes

Palettes contain additional options for working with tools and images. Related palettes are grouped together to enable you to work more efficiently. You can also store frequently used palettes in the Palette Well and save your palette layout by selecting Window > Workspace > Save Workspace.

### Navigator Palette

This palette zooms in and out of an image. You can also use it to move to a specific position within an image.

### Info Palette

The Info palette displays color values, angles, and coordinates for a point or selection. It also shows the width and height of a selection. The palette shows information about the currently selected tool and the size of the image.

### Histogram Palette

This palette displays a bar graph of the color information within an image.

### Color Palette

The Color palette allows you to select and mix colors.

### Swatches Palette

This palette contains frequently used colors. You can add new colors or delete existing colors. You can also load different swatches.

### Style Palette

The Style palette stores layer styles.

## History Palette

The History palette shows a list of the most recent steps that you've carried out. You can use the palette to undo one or more of these steps. The History palette can also store image snapshots (basically, history bookmarks).

## Actions Palette

You can use the Actions palette to record and play back common actions. This can save time when you want to repeat the same actions.

## Layers Palette

The Layers palette allows you to work with layers in an image.

## Channels Palette

The Channels palette shows and modifies the color and alpha channels within an image.

## Paths Palette

This palette manages paths within an image.

## Character Palette

The Character palette sets options for text characters.

## Paragraph Palette

This palette sets options for paragraphs of text.

## Layer Comps Palette

This palette saves layer combinations so you can work with multiple versions of the same image.

## Animation Palette

You can directly turn the image being worked on into an animation. Create a frame using the animation palette, and create a serial animation by editing each frame.

## Brushes Palette

The Brushes palette sets the properties of brushes.

## Clone Source Palette

You can adjust five selection areas at once with the tool that designates the image copying method, using the Stamp tool. Also, you can adjust the copied image at will, for example with magnification, size reduction, gradient, and the proportion of the upper, lower, right and left sides.

21

## Understanding Color Modes

When creating or converting images in Photoshop, you must decide which color mode to use. Photoshop offers numerous color modes, and each is tailored to a specific application or purpose. In this section we'll introduce the available options.

**Bitmap:** This mode shows only black and white.

- An image in Bitmap mode uses black and white in varying densities.
- When the image is enlarged, you can see the black and white pixels.

**Grayscale:** Grayscale lets you work with up to 256 shades of gray.

- A value of 0 is black while 255 is white. The numbers in between are shades of gray.
- You can see the gray pixels when you enlarge the image.

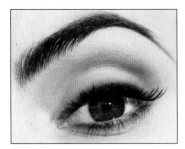 

**RGB Color:** The RGB Color mode uses three colors to compose a full spectrum of color—red, green, and blue. It can be used to display up to 16.7 million colors and it's the mode used by computer monitors. This is the most commonly used mode in Photoshop, and it allows for the most filters and effects within the program.

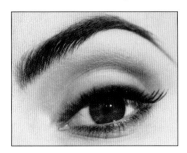 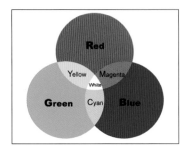

**CMYK Color:** CMYK is used for printing images. Images in this mode are composed of four channels: cyan, magenta, yellow, and black. Colors are created by specifying percentages for each of these four colors. The more the CMYK colors are mixed together, the darker the resulting color becomes. This is different from RGB mode, in which adding more RGB colors produces a lighter finished color.

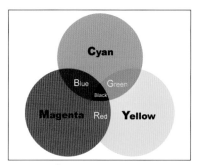

**Lab Color:** The Lab Color mode uses luminance (or lightness) as well as two color axes to create colors. The A axis contains colors between green and red, and the B axis contains colors between blue and yellow. Photoshop uses lab color when converting between color modes.

**HSB Color:** HSB uses hue, brightness, and saturation to describe colors.

- Hue is the color and is indicated by a value between 0 and 360.

- Brightness indicates the lightness or darkness of the color. This is measured as a percentage between 0 and 100.

- Saturation indicates the intensity of color as a percentage between 0% and 100%. The higher the percentage, the closer the colors are to primary colors. A saturation of 100% is referred to as a "pure" color.

tip >>

**Selecting Color Modes**

- You can change the color mode at any time using Image > Mode, and you should choose the correct mode for the task at hand. The Bitmap mode creates line art images in black and white. Grayscale creates images that are black, white, and gray. Online images, such as those used for a Web site or presentation, use the RGB mode. CMYK is used for printed images.
- When creating images for print, it's best to start with the RGB mode and convert to CMYK as the final step. This is necessary because you can't use all of Photoshop's filters in CMYK mode.

## Photoshop File Formats

Photoshop supports a variety of file formats so that you can create images for different purposes and share them with other programs. You can specify the file format when you use the File > Save or Save As commands to save an image. Photoshop supports the following file formats.

### Photoshop (*.PSD, *.PDD)

This is Photoshop's native file format. Photoshop files tend to be large, but this is because they retain information related to layers, channels, and effects to maximize the editing potential of your images. You can save finished images in another format to reduce the file size.

### BMP (*.BMP, *.RLE, *.DIB)

The bitmap format is the most basic graphic format. You need to choose the operating system, either Windows or OS/2, when you save files in this format. You also need to set the image depth (which determines the potential number of colors in the image), up to 32 bits. This format doesn't save channel and layer information.

### Compuserve GIF (*.GIF)

GIF (Graphic Interchange Format) was developed to compress image sizes. This format is common for Web images and it supports transparency and animation. GIF images can display up to 256 colors (8 bits).

### Photoshop EPS (*.EPS)

The EPS (Encapsulated PostScript) format is typically used when images are to be used in programs such as Illustrator, PageMaker, and QuarkXPress. EPS is normally used for printed images and is often used in CMYK mode. EPS allows you to save paths but not alpha channels.

### Photoshop DCS 1.0 (*.EPS) and Photoshop DCS 2.0 (*.EPS)

DCS (Desktop Color Separations) format allows EPS images to be saved in four separate files and one master file. The DCS 2.0 format can include spot channels for images with spot colors.

### JPEG (*.JPG, *.JPEG, *.JPE)

The JPEG (Joint Photographic Expert Group) format is another compressed format that is common on Web pages. A JPEG image can show up to 24-bit color, so this format is useful for photographic images and those with many colors. You need to set the compression ratio when you use this format. A higher compression setting results in lower-quality images and smaller file sizes.

### PCX (*.PCX)

The PCX format was created for the exchange of ZSoft PC Paintbrush files.

### Photoshop PDF (*.PDF, *.PDP)

Photoshop PDF (Portable Document Format) is compatible with Adobe Acrobat, allowing Photoshop to work with PDF files.

### Photoshop RAW (*.RAW)

The RAW format contains raw pixel information, so it is a flexible file format. It is often used to transfer images between different computers.

## PICT File (*.PCT, *.PICT)

PICT is the standard graphic format for Macintosh computers. RGB images saved in this format can use either 16- or 32-bit color. JPEG compression is possible when 32-bit color is used.

## Pixar (*.PXR)

The Pixar format was created by Pixar, an animation company.

## PNG (*.PNG)

The PNG (Portable Network Graphics) format creates compressed images that allow transparency. This format can use 8- or 24-bit color. Compared with JPEG, 24-bit PNG creates larger file sizes. PNG is a recent file format that may not be compatible with older Web browsers.

## Portable Bit Map(*.PBM;*.PGM;*.PPM,*.PNM;*.PFM)

PBM file formats are black and white single images. The image will be lost while converting the image into file formats that can be easily used.

## Scitex CT (*.SCT)

Scitex CT (Scitex Continuous Tone) is a format used for exchanging files with Scitex computers.

## TGA (*.TGA, *.VDA, *.ICB, *.VST)

TGA (Targa) was developed by Truevision for the Targa and Vista video boards. This format works with both PC and Macintosh computers and supports 24- and 32-bit color.

## TIFF (*.TIF, *.TIFF)

TIFF (Tagged Image File Format) allows for sharing between different computer platforms and programs. Most graphics software packages support this format. TIFF includes LZW compression, which doesn't decrease the quality of an image. It also produces smaller file sizes compared with EPS images. TIFF also supports ZIP compression and preserves transparency.

tip >>

### Choosing the Correct File Format

You can use many different file formats in Photoshop. To decide which format you want to use, you'll need to think about how you'll be using the finished image.

**Incomplete Images or Those That Require Correction**

If you haven't finalized an image, it's most useful to save it in the Photoshop (*.PSD) format. This format allows you to continue working with layers, channels, and paths.

**Desktop Publishing Images for Print**

If the image will be used in a desktop publishing program to create files for print, save it in the EPS format. This allows you to use paths within the DTP program. If you don't need to use paths, save the image in the TIFF format.

**Web Images**

GIF and JPEG images are used in Web pages because they compress the file size and create faster-loading pages. GIF supports transparency and animation without changing the image quality. In the JPEG format, you can set the compression ratio to create a balance between file size and image quality.

# Creating a Simple Image

I n this section, you will create and save a new image file. In the process, you'll start to acquaint yourself with basic Photoshop operations.

## Creating a New Image

You can create a new image by choosing File > New. This will display the New dialog box.

**The New Dialog Box**

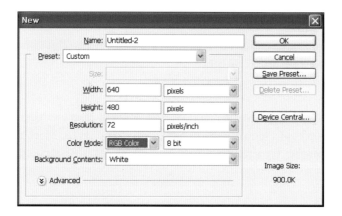

**Ⓐ Name:** Type in the name of the created file.

**Ⓑ Preset:** Sets the image size from a range of preset sizes.

* Custom: The user determines the image size.
* Clipboard: Uses the size of the last object that was copied to the clipboard.
* Default Photoshop Size: The default size is a 72 pixels/inch image measuring 7 inches in width and 5 inches in height.
* U.S.paper: You can select Letter, Legal, or Tabloid.
* International Paper : You can select from A6, A5, A4, A3, B5, B4, and B3 plate types, as well as C6, C5, C4, and DL sizes.
* Photo: You can set the size of the document to 2×3, 4×6, 5×7, or 8×10, which are the most frequently used sizes for photos.
* Web: You can set the Web sizes according to screen sizes of 640×480, 800×600, 1024×768, 1152×864, 1280× 1024, and 1600×1200.

- Mobile & Devices: You can set the size of the screen to suit cellphone screen sizes.
- Film & Video: You can set the size of the document for various broadcasting screen sizes.

**Ⓒ Size :** You can select various screen sizes according to the Preset.

**Ⓓ Resolution:** The resolution represents the amount of detail within an image. Higher resolutions include more detail. They also result in larger file sizes. Web images normally use a setting of 72 pixels/inch, while print images use 300 pixels/inch.

**Ⓔ Color Mode:** Select the color mode for your new image here. The pull-down menu to the right allows you to set the per-channel color depth (1, 8, or 16 bits). This value, when multiplied by the total number of color channels in the selected color mode, gives the total color depth of your image. RGB Color, for instance, yields a color depth of 24 bits (8 bits per channel x 3 channels). Increasing the value to 16 allows for even more colors, but this won't noticeably improve the quality of your images, as the human eye can only perceive so many colors.

- Bitmap: Contains only black and white.
- Grayscale: Contains shades of gray.
- RGB Color: Contains up to 16.7 million colors made up of combinations of red, green, and blue.
- CMYK Color: Contains printing colors made up of cyan, magenta, yellow, and black.
- Lab Color: Contains a luminance component and two color elements: a: green to red, b: blue to yellow.

**Ⓕ Background Contents**
- White: Fills the background with white.
- Background Color: Fills the background using the current background color from the Toolbox.
- Transparent: Creates a transparent background.

## Drawing a Simple Graphic

In this Section, let's draw and save a simple image.

1. Choose File > New (Ctrl-N) to create a document in which to draw a new image.

2. When the New dialog box appears, enter the name 'cat' for the document and set Web in the Preset Drop-down menu. Set the size to 640×480, and click OK.

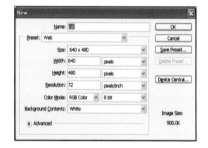

3. Select the Brush tool () in the Toolbox. Select the Brush Preset Picker on the option bar and set the size of the brush to 5px.

tip >>

**The Undo Command**

If you make a mistake and want to undo the last step, use Edit > Step Backward (Shift-Ctrl-Z). You can repeat this to undo several steps.

4. The title bar of the image shows the image name (cat) and that the image is set to 100% magnification. Use the Pencil tool to draw the cat as shown. Since you will fill the image using the Paint Bucket tool, you should make sure there are no spaces between the lines.

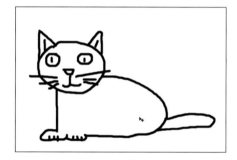

5. Select the Paint Bucket tool (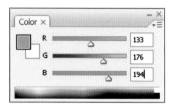) from the Toolbox. Set the color in the Color palette as shown. You can either drag the sliders or enter the numbers. This will select a blue color.

6. Click inside the various areas of the cat with the Paint Bucket tool to fill them with blue.

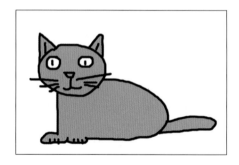

## Saving the Image File

1. Choose File > Save to bring up the Save As dialog box. Choose a location and click Save. Because we already named the image, the name "cat" appears automatically. Choose JPEG as the format for the image.

2. When you choose the JPEG format, the JPEG Options dialog box allows you to set the compression for the image. Choosing lower values for Quality creates smaller file sizes but the image quality also declines. In this example, choose 8 and click the OK button.

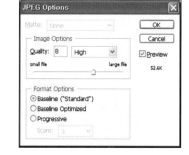

3. The image has been saved. Close Photoshop by choosing File > Exit.

### File > Save Options

Note>>>

- **Save:** This command saves using the current filename, format, and location. If you haven't saved the file before, the Save As dialog box appears instead.
- **Save As:** Saves the file with a new filename, location, or format. The creates a copy of the original image, unless it's the first time you've saved the document.
- **As a Copy:** Check this option in the Save As dialog box to create a backup. This saves a copy without affecting the current image.

# Adobe Bridge

The software package Adobe Bridge is included with all programs in Adobe Creative Suite 3, including Photoshop CS3. Adobe Bridge looks similar to the File Browser found in Photoshop CS, but it includes a number of additional features. In addition to providing an excellent environment in which to preview images, Adobe Bridge is also useful as a cataloguing tool.

## Getting Started

There are three ways to run Adobe Bridge: First, you can click the Bridge icon (🔲) in the Options bar; second, you can choose File > Browse; third, you can use the shortcut Alt-Ctrl-O.

To have Adobe bridge open automatically whenever you start Photoshop, select Edit > Preferences > General, and check The Adobe Bridge Window.

## The New Dialog Box

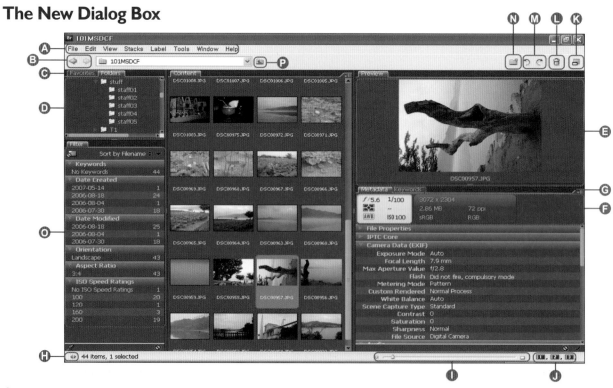

**Ⓐ Menu bar:** Bridge includes seven menus.

**Ⓑ Go Back and Go Forward buttons:** You can use these buttons to navigate through folders that you've already visited.

**Ⓒ Favorites palette:** This works like the favorites menu in Internet Explorer. You can add commonly used folders to your Favorites palette so you can access them quickly. When you right-click a folder or file listed as a favorite, you'll see a context menu. You can choose Remove from Favorites to delete the folder from the Favorites palette. You can also choose Reveal in Explorer to open the folder in Windows Explorer.

| Remove from Favorites |
|-----------------------|
| Reveal in Explorer    |

**Ⓓ Folders palette:** This shows the folders on your computer. You can move between folders using your mouse or the direction keys on the keyboard. Pressing the F5 key refreshes the folders list.

tip >>

**Opening or Closing Palettes**

You can double-click a palette tab to collapse it quickly.

**Ⓔ Preview palette:** Previews the selected image.

**Ⓕ Metadata palette:** Provides information about the currently selected image.

tip >>

**Metadata**

Metadata is information about the image, including the date and time that the image was created, the image size, and the resolution. It uses a standard method called the Extensible Metadata Platform (XMP).

**Ⓖ Keywords palette tab:** You can use this palette to apply keywords to classify an image. The palette allows you to use keyword sets that contain individual keywords. When you choose only one item in a keyword set, ▣ is displayed; when all items are checked, Bridge displays ☑.

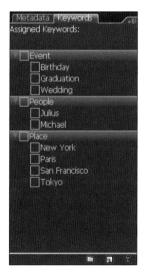

**Ⓗ Show/hide Panels tab:** You can show or hide the palettes on the left.

**Ⓘ Thumbnail Size slider:** This adjusts the size of the thumbnails.

**Ⓙ Content Display buttons:** These buttons change how images are displayed. They represent the frequently used modes for viewing images.

tip >>

**Shortcut**

Use the Ctrl-+ and Ctrl - – shortcuts to increase and decrease thumbnail sizes. Note that you can't use the + and – keys on the numeric keypad.

**Ⓚ Window Mode Change button:** This enables you to change the display of the Bridge window.

- The Compact mode button ( ▢ ) allows you to reduce the size of the Bridge window, as shown at right.
- From Compact mode, you can press the Ultra compact mode button ( ▢ ) to make the Bridge window even smaller.
- When you click the Switch to Full mode button ( ▢ ) from

Compact or Ultra compact mode, the Bridge window returns to Full mode.

**Ⓛ Delete button:** Moves the selected file(s) to the Recycle Bin.

**Ⓜ Rotate buttons:** These rotate the selected image clockwise or counterclockwise by 90°.

**Ⓝ Create a New Folder button:** Creates a new folder within the currently selected folder.

**Ⓞ Unfiltered/Filtered menu:** This menu allows you to apply filters to selected images.

**Ⓟ Up One Level button:** This button navigates the browser one folder "up" in the file directory.

## Opening Files in Bridge

You can open a file in Bridge in several different ways.

- Use the Ctrl-O shortcut.

- Double-click an image.

- Right-click an image and select Open or Open with from the menu.

# Exercise 01

## Making a Slide Show

Final image

In this exercise, we will create a slide show using Adobe Bridge.

Start Files

\Sample\Chapter01\Silde Show

**1** Copy the folder \Sample\Chapter01\Slide Show to the hard disk of your computer. When it is copied to the hard disk, select the Slide Show folder with Bridge.

**2** Now you are prepared to play a slide show. Start the slide show from the first picture file by pressing Ctrl-L.

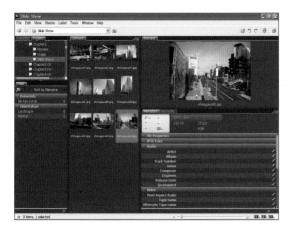

**4** The slide show starts again when you press the spacebar on the keyboard.

**3** When you press the H key on the keyboard, help information appears.

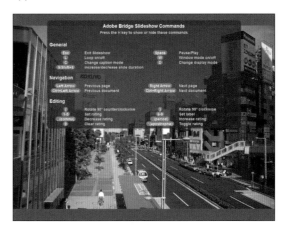

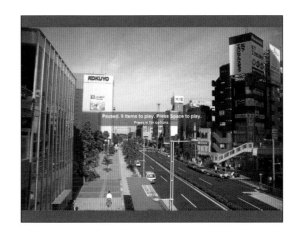

**5** When you press the spacebar, images will appear one after the other automatically. If you wish to proceed manually, press the right arrow key on the keyboard.

**6** Bridge also allows you to modify images during playback. The [ key on the keyboard rotates the image 90° counterclockwise, while the ] key rotates it 90° clockwise. The comma key lowers an image, while the period key raises it. The number keys from 6 to 9 determine how the images are labeled.

# 02

# Making a Web Photo Gallery

In this exercise, we'll create a Web photo gallery using Bridge. The Web photo gallery we create generates thumbnails and images that can be viewed in a Web browser such as Internet

Start Files
\Sample\Chapter01\Flowers

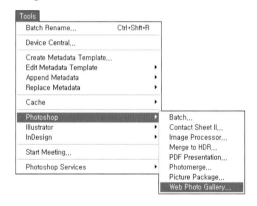
Final image

**1** Copy the folder \Sample\Chapter01\Flowers to the hard disk of your PC.

**2** Select Tools > Photoshop > Web Photo Gallery from the Bridge menu.

**4** For Source Images, select either Folder or Selected Images from Bridge. Here we will select Folder, specifically the Flowers folder you copied to your hard disk. If there are subfolders, select Include All Subfolders. In Destinations, you specify the folder in which the files created for the gallery will be stored. In this case, create C:\Web_photo_gallery.

**6** When all the settings are entered, click OK. You will see the process of file generation in Photoshop.

**3** When Photoshop opens, the Web Photo Gallery dialog box appears. Here, select the style in which you want to create the gallery. For example, select Centered Frame 1 -Feedback from Styles. The e-mail address defined here is displayed on the Web page created by Photoshop.

**5** Select how the photo gallery will be displayed from the Options drop-down menu. Here we will select Thumbnails and use the default values for the other options.

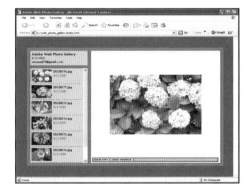

**7** You can now see the completed Web photo gallery.

35

Chapter | **2**

# Making Selections

Photoshop includes a number of tools that allow you to select specific parts of an image for editing. Each of these tools offers a unique method for making selections. In this chapter, we'll review these methods and discuss some of the tasks for which certain tools are best suited.

# Selection Tools and the Select

In this chapter, we'll look at some of the tools and commands that can be used to select parts of an image, including the Marquee, Lasso, and Magic Wand tools. You'll be able to practice working with these tools in the examples at the end of the chapter.

## The Marquee Tools

The marquee tools make selections based on shapes. These include the Rectangular Marquee tool, Elliptical Marquee tool, Single Row Marquee tool, and Single Column Marquee tool. Let's start with a basic overview of each tool and then examine the options available for each.

### Overview

The Rectangular Marquee tool (  ) and Elliptical Marquee tool (  ) create rectangular and circular selections within an image. Click and drag the mouse on the image to create the selection. You can hold down the Shift key to create a perfect square or circle.

Selecting with the Rectangular Marquee tool

Selecting with the Elliptical Marquee tool

The Single Row Marquee (  ) and Single Column Marquee (  ) tools select a one-pixel wide horizontal or vertical line.

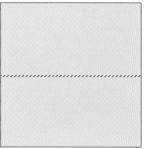 

Selecting a horizontal line with the Single Row Marquee tool

Selecting a vertical line with the Single Column Marquee tool

tip >>

Selecting Horizontal and Vertical Lines

You should be careful when using the Single Row and Single Column Marquee tools because it can be hard to see what has been selected in your image.

You may want to zoom in before you use these tools so you can make an accurate selection.

## Options Bar of the Marquee Tools

The image below shows the options available for the Rectangular Marquee tool. The Options bar looks slightly different when the Elliptical Marquee tool is selected. Changes made to these values will take effect the next time you use the selected tool.

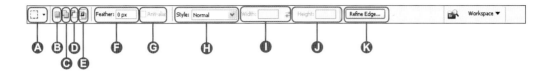

**A** **Tool Presets picker:** This button allows you to use selection tool values that you've previously saved. Save the current settings by opening the Tool Presets picker and clicking the "Create new tool preset" button.

tip >>

**Current Tool Only**

You can check the Current Tool Only option to display presets that relate only to the currently selected tool.

**B** **New selection ( ):** Creates a new selection from the area that you have dragged.

**C** **Add to selection ( ):** Adds to the existing selection the next time you use a marquee tool. You can also do this by holding down the Shift key as you make your next selection.

**D** **Subtract from selection ( ):** Excludes the newly selected area from the current selection. This is the same as holding down the Alt key when you make your next selection.

**E** **Intersect with selection ( ):** When you make your next selection, only areas that intersect with the existing selection will be selected. This is the same as holding down the Shift and Alt keys while selecting.

**F** **Feather:** This option softens the edges of your next selection. You can enter values between 0 and 250 pixels. Higher numbers create softer edges. The images here show the effects of Feather values of 0, 5, and 20.

**G** **Anti-aliased:** You can use this option with the Elliptical Marquee tool. It is used to smooth the edges of elliptical or circular shapes.

**H** **Style:** The Style drop-down box allows you to specify how the selection should be made. The Normal style doesn't restrict your selection. If you select Fixed Aspect Ratio, you'll need to select the proportions for the width and height of your selection. (For example, if you enter a value of 2 for the width and 1 for the height, your selected area will be twice as wide as it is high.) Choosing the Fixed Size option allows you to enter a specific height and width in pixels.

**I** **Width:** This is a function for smoothly adjusting the edges that are applied to the selected area using dialog box. You can adjust the edge with various options. When the edges have been adjusted, and [OK] is pressed, the option value is applied to the selected area.

**𝗝 Height:** Move to the [Adobe Bridge] where you can search for images.

**𝗞 Refine Edge:** This brings up a dialog box to adjust the characteristics of the edges that are applied to the selected area. Use the following controls to adjust the edges. Click OK to apply the option value to the selected area.

*Radius:* Adjust the smoothness of the outline of the selected area's image.

*Contrast:* Adjust the contrast of the smoothness of the adjusted selected area.

*Smooth:* Soften the area in the angled parts in the selected area.

*Feather:* Apply the feather to the selected area.

*Contract/Expand:* Expand or shrink the selected area.

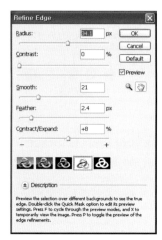

tip >>

| Refine Edge |
| --- |

Adjust with [Refine Edge] and press [OK]. There are no changes in the image. The option value is applied only to the selected area. To check the adjusted selected area, press [Delete] to delete the image, or apply another color to the selected area by pressing [Alt]-[Delete]. You can confirm that the [Refine Edge] has been applied.

## The Lasso Tools

The Lasso tools include the Lasso tool, Polygonal Lasso tool, and Magnetic Lasso tool. You can make freeform selections using the Lasso and Polygonal Lasso tools. The Magnetic Lasso tool creates selections by tracing edges within an image.

## Overview

The Lasso tool (🔲) creates freehand selections as you click and drag your mouse over an image. The shape you draw is automatically "closed" when you release the mouse button. It can be difficult to create an accurate selection with this tool.

Click the starting point and drag the tool without releasing the mouse button.

When you release the mouse button, a selection will appear in your image.

The Polygonal Lasso tool ([icon]) creates points each time you click the mouse. Each point is joined by a straight line from the previous point. When you are finished, you can click the starting point or double-click to complete the selection. This tool is effective for selections that include straight lines. You can remove the last segment that you drew by pressing the Delete key. Press Esc to delete all of the lines.

Click along the edges of the desired selection. Each time you release the mouse button, you will create a straight line from the previous

Click to add additional straight lines to the selection. You can finish the selection by double-clicking or clicking your starting point.

The Magnetic Lasso tool ([icon]) allows you to trace objects within an image. It does this by aligning itself automatically to edges that have sharp contrast, so it's particularly useful in images that feature sharp edges with clear color definition. Click to set the starting point, then drag the mouse along an edge; a selection will be created automatically. You can also click to add reference points to the selection. When you have finished, drag to the starting point or double-click. Press Delete to delete the selection to the previous reference point.

Click to set the starting point, then move the mouse along the border of the object.

tip >>

**Using the Alt/Option Key with the Lasso Tool**

- If you're using the Lasso tool, you can use the Alt key to create straight lines, as you would with the Polygonal Lasso tool.

- If you have the Polygonal Lasso tool selected, pressing Alt allows you to create freehand selections, as you would with the Lasso tool.

- If you're working with the Magnetic Lasso tool, the Alt key allows you to create freehand selections as if you were using the Lasso tool. You can also click the mouse to add straight-line selections, as with the Polygonal Lasso tool.

## Options Bar of the Magnetic Lasso Tool

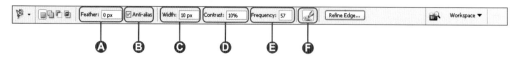

**Ⓐ Feather:** Softens the edges of the selection.

**Ⓑ Anti-alias:** Turns on anti-aliasing for smoother curves.

**Ⓒ Width:** Sets the detection width of the Magnetic Lasso tool in pixels. You can enter values from 1 to 256. The lower the number, the closer you'll need to be to an edge for a selection to be made. If you turn on the \ Caps Lock key you'll be able to see the detection area more easily.

**Ⓓ Contrast:** This determines how the object edge is detected. When you enter a higher value, the border is selected more accurately. However, selecting a number that's too high can result in a jagged selection.

**Ⓔ Frequency:** This determines how many reference points are added to the selection. You can enter values between 0 and 100.

**Ⓕ Use tablet pressure to change pen width:** With this option checked, the pressure of the pen is recognized when using the tablet.

tip >>

**Entering Numbers in the Magnetic Lasso Tool Options Bar**

You can only enter whole numbers for the Frequency setting. You can enter decimal numbers for the Feather, Width, and Edge Contrast settings.

## Quick Selection Tool

If you click a spot in an image using the Magic Wand tool, a selection will be created based on the color of the spot you clicked. Because this can be a difficult tool to master, it's important to understand the options available for it.

Whereas the Selection tools discussed so far are used by clicking and dragging around the outline ofe a selected area, the Magic Wand tool lets you create a selected area just by clicking once, and the Quick Selection tool, newly added to Photoshop CS3, enables you to create selected areas quickly by dragging the mouse over them, as when using the Brush tool. These two tools let you easily create selected areas by clicking or dragging and therefore are useful for beginners or those who need to create selected areas quickly.

# Overview

The Quick Selection Tool ( ) is a tool that creates selected areas by dragging over the image, just as when coloring an image with the Brush tool. By setting the size of the brush, you can adjust the selected area's size accordingly and create selected areas quickly.

A Tolerance of 32

A Tolerance of 150

# Option Bar of the Quick Selection Tool

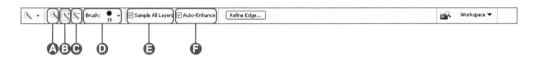

Ⓐ **New Selection:** Creates new selected areas.

Ⓑ **Add to Selection:** Adds the dragged area to the current selected area.

Ⓒ **Subtract from Selection:** Excludes the dragged area from the current selected area.

Ⓓ **Brush:** Adjusts the size of the brush used to create the selected area.

Ⓔ **Sample All Layers:** Immediately turns the image in all layers into selected areas.

Ⓕ **Auto-Enhance:** When the option is checked, automatically adjusts the rough parts of the selected area which is created by dragging, and makes them smooth.

# Option Bar of the Magic Wand Tool

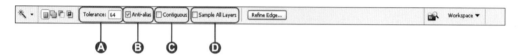

**Ⓐ Tolerance:** Determines how closely the selection will match the clicked color. The default setting is 32,Band you can enter values from 0 to 255. As you increase the value, the tool selects larger areas with a wider range of colors.

**Ⓑ Anti-alias:** Turn anti-aliasing on to create selections with smoother curves.

**Ⓒ Contiguous:** When you choose the Contiguous option, the selection only includes areas that are adjacent to the clicked color. If you deselect this option, colors in non-adjacent areas will also be selected.

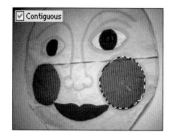

Contiguous option checked: Selects colors from areas adjacent to the clicked point

Contiguous option not checked: Selects colors anywhere in the layer

**Ⓓ Sample All Layers:** If this option is selected, the tool will recognize colors from all the visible layers in your image. If you deselect this option, the Magic Wand tool only selects colors from the current layer.

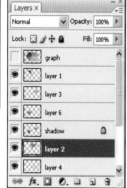

Sample All Layers option checked: Selects colors only from all visible layer

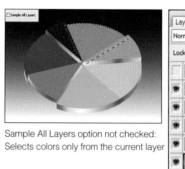
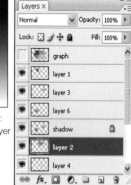

Sample All Layers option not checked: Selects colors only from the current layer

## The Select Menu

If you click a spot in an image using the Magic Wand tool, a selection will be created based on the color of the spot you clicked. Because this can be a difficult tool to master, it's important to understand the options available for it.

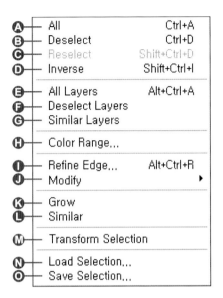

**ⓐ All (Ctrl-A):** Selects the entire image.

**ⓑ Deselect (Ctrl-D):** Removes the selection.

**ⓒ Reselect (Shift-Ctrl-D):** Reselects a selection that was deselected.

**ⓓ Inverse (Shift-Ctrl-I):** Inverts the selection so that previously unselected areas become selected and areas that were selected become deselected.

**ⓔ All Layers (Alt-Ctrl-A):** Selects all layers.

**ⓕ Deselect Layers:** Deselects selected layers.

**ⓖ Similar Layers:** Selects similar layers. For example, you can use this option to select all type layers.

**ⓗ Color Range:** Creates a selection based on a sampled color. You can control the selection by using the Fuzziness setting. Increasing the fuzziness increases the area that is selected. You can also choose to preview the selection.

**ⓘ Refine Edge:** Adjusts the smoothness of the selected area's outline, using the Refine Edge dialog box, as with the Marquee tools. Adjustments are not applied to the whole image but only to the selected area.

**ⓙ Modify:** Use Modify to change the current selection. Modify includes the following options:

*Border:* Frames a selection with a border.
*Smooth:* Smoothens the selection using the specified pixel range.
*Expand:* Expands the selection by a specified number of pixels.
*Contract:* Contracts the selection by a specified number of pixels.
*Feather:* Softens the outline of the selected area like feathers.

**Ⓚ Grow:** Expands the selection to include adjacent pixels based on the Tolerance setting in the Magic Wand tool Options bar.

**Ⓛ Similar:** Expands the selection to include all pixels in the image that fall within the Tolerance setting in the Magic Wand tool Options bar.

**Ⓜ Transform Selection:** Allows you transform a selection freely. Transformation techniques are covered in depth later in this book.

**Ⓝ Load Selection:** Loads a saved selection.

**Ⓞ Save Selection:** Saves the selection so you can load it later.

## Saving Selections

Photoshop allows you to save selections, then reload them for later use. Choose Select > Save Selection and enter a name in the Save Selection dialog box. Click OK to save the selection. You can then load the saved selection by choosing Select > Load Selection. Choose the name of the selection and click OK. The selection will appear in the image.

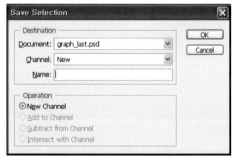

Save Selection dialog box

Load Selection dialog box

# Advanced Selection Methods

**B**eyond the selection tools and Select menu, Photoshop offers additional selection methods geared toward power Photoshop users. Not to worry, you'll count yourself in that group soon enough!

## Quick Mask Mode

Quick Mask mode allows you to create detailed selections using painting tools. Use this mode to mask areas that are not to be included in the selection.

When you paint an area while in Quick Mask mode, it will be highlighted in red; this indicates that it will be excluded from your selection. When you enter Quick Mask mode, the phrase "Quick Mask" will appear in the title bar of the image window.

### Setting the Options for Quick Mask Mode

Double-click the Quick Mask icon (⬚) to display the Quick Mask Options dialog box.

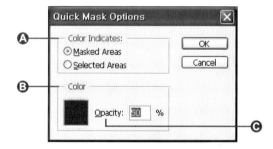

**Ⓐ Color Indicates:** The default setting is Masked Areas. With this setting, painted areas are excluded from the selection. If you haven't changed the default color, these areas will appear in red. If you change the setting to Selected Areas, painted portions of the image will be added to the selection.

**Ⓑ Color:** The selected color will be used to highlight the masked/painted areas within the image. The default color is a good choice, since it will help you distinguish the masked areas easily.

**Ⓒ Opacity:** Sets the opacity of the mask color. It's a good idea to use the default value of 50%. Higher values may hide parts of the image and make it difficult to create complicated selections.

tip >>

To save masks permanently as selections, return to Standard mode and choose Select > Save Selection. The selection will be saved as an alpha channel. You will learn more about channels in Chapter 8.

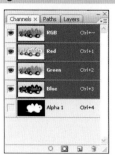

## The Color Range Command

You can use the Color Range command to create selections based on the colors in an image. This option allows you to create complicated selections by sampling colors and changing the Fuzziness setting. You can preview the selection in the Color Range dialog box as you work. Let's look The Color Range Dialog Box in the Color Range dialog box.

## The Color Range Dialog Box

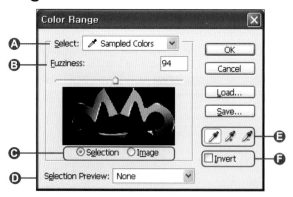

ⓐ **Select:** Sets the target colors for the selection.

ⓑ **Fuzziness:** Choose higher numbers to create larger selections.

ⓒ **Selection/Image:** Choose Selection to see the selected areas in black-and-white. Choose Image to display the current image.

ⓓ **Selection Preview:** Determines whether the selection is previewed in the larger image window. Also allows you to choose a preview style.

ⓔ **Invert:** Inverts the selection.

ⓕ **Eyedropper:** Click the image with the eyedropper to choose your sample pixels. You can also use the eyedropper to add and exclude pixels.

**Exercise**

# 01

# Selecting and Replacing Colors

Final image

Selecting is one of the most important skills in Photoshop, so it's good to practice. In this exercise, we will create a selection and use it to change a woman's lipstick color.

┌ Start Files
└ \Sample\Chapter02\Lip.jpg

┌ Final File
└ \Sample\Chapter02\Lip_end.jpg

---

**1** Open Lip.jpg. Select the Magic Wand tool from the Toolbox and click on the upper lip.

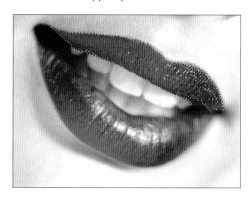

tip >>

**Resource Files**

Remember to copy the resource files on the CD-ROM to your hard drive before you start each exercise in this book.

**2** Click Add to selection () in the Options bar and click on the lower lip.

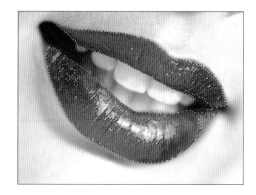

tip >>

**Tolerance**

The Tolerance affects the selection made by the Magic Wand tool. The default value is 32 and you can enter numbers between 0 and 255. As you increase the value of this setting, the selection area increases.

**3** The Magic Wand tool (⟍) won't select areas that are outside the Tolerance value set in the Options bar. You can use the Lasso tool (⟳) to add any unselected areas within the boundaries of the lips.

**4** Remove areas from the selection by clicking Subtract from selection (⟳) in the Options bar. Continue until you are satisfied with the selection.

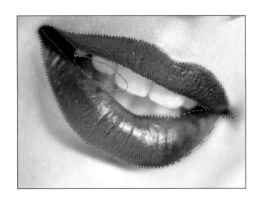

**5** Change the lip color by choosing Image > Adjustments > Color Balance. Move the second slider towards Magenta to a value of -50. Move the third slider towards Blue to a value of 70. Check the Preview option so you can see the changes you are making. Click OK when you're finished. The final image is shown at the beginning of this exercise.

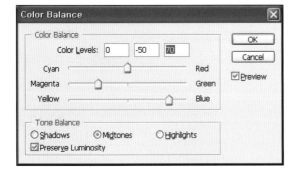

tip >>

### Adding to Selections Using the Shift Key

You can also hold down the Shift key while making selections to add to existing selections.

tip >>

### Using the Alt Key

You can also subtract from the selection area by holding down the Alt key when you use a selection tool.

# Changing the background image

Final image

As a demonstration of the power of the Quick Selection tool in Photoshop, in this exercise we will use it to change the appearance of both the open sky above a building and the sky showing through its many arches.

Start Files
\Sample\Chapter02\Colosseum.jpg

Final File
\Sample\Chapter02\Colosseum_end.jpg

**1** Open Colosseum.jpg. Select Quick Selection Tool (🖊) from the Toolbox, and select Add to Selection (🖊) option on the option bar. Input '24px' as the diameter of the brush option.

| Diameter: | 24 px |
| Hardness | 63% |
| Spacing: | 84% |
| Angle: | 0° |
| Roundness: | 100% |
| Size: | Off |

tip >>

### Creating a selected area with the Quick Selection Tool

This Quick Selection Tool enables you to create selected areas as if dragging the selected area with the Brush tool. Therefore, the size of the selected area is also adjusted by the size of the brush.

**3** Drag to the right from the left part of the Colosseum.jpg image, and make the sky part of the image into the selected area.

**2** Drag to the right from the left part of the Colosseum.jpg image, and make the sky part of the image into the selected area.

**4** To add a simple effect to the sky area, choose Filter > Render > Clouds on the menu bar. The image can be changed into a dark, cloudy sky. Exit the selected area mode by pressing Ctrl-D.

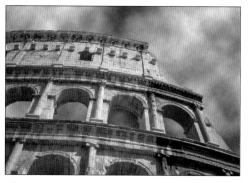

tip >>

### To create dark and cloudy sky effects

The Clouds filter is influenced by the Foreground Color and the Background Color. If the cloudy effect does not appear as in the image, select the basic colors of black and white for the Foreground Color and Background Color (under the Toolbox).

# 03

# Creating a Reflection

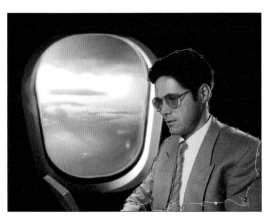

Final image

Can you see the difference between these two images? The second image shows a reflection in the window. We'll create this reflection by altering the opacity and blend mode of a duplicate

Start Files
\Sample\Chapter02\Window.jpg

Final File
\Sample\Chapter02\Window_end.psd

**1** Open Window.jpg. Select the Magnetic Lasso tool (🔎) and set its Feather value to 5 in the Options bar. Click on the edge of the man's face and drag around his head and shoulders. When you return to the starting point, click on it (it's depicted by a circle) to finish the selection.

**2** Select Edit > Copy to copy the selection, then choose Edit > Paste to paste the copied selection. The Layers palette will show a new layer, Layer 1.

**3** Select the Move tool (⊹) from the Toolbox and drag the image to the plane's window, as shown.

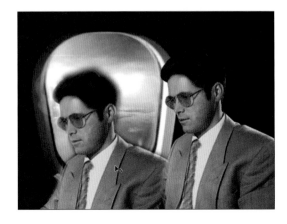

**4** In the Layers palette, set the Opacity of Layer 1 to 70%. Since only the upper part of the man should be reflected in the window, we'll have to erase the other parts of the layer. Select the Lasso tool ( ) and set the Feather value to 5. Use the mouse to select the parts of the image that won't be reflected in the window.

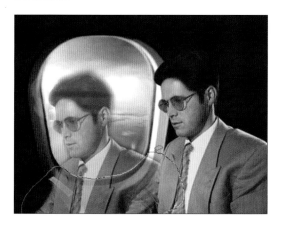

**5** Press Delete to delete the selected area and choose Select > Deselect to clear the selection.

**6** To create a natural reflection, you can choose an alternate blend mode in the Layers palette. Select Soft Light from the dropdown box at the top of the Layers palette. The final image is shown above.

Normal
Dissolve

Darken
Multiply
Color Burn
Linear Burn
Darker Color

Lighten
Screen
Color Dodge
Linear Dodge (Add)
Lighter Color

Overlay
Soft Light
Hard Light
Vivid Light
Linear Light
Pin Light
Hard Mix

Difference
Exclusion

Hue
Saturation
Color
Luminosity

# Using Quick Mask Mode to Create a Selection

In this exercise, we'll use Quick Mask mode to isolate the woman from the background.

Final image

Start Files
\Sample\Chapter02\Summer.jpg

**1** Open Summer.jpg. Use the Rectangular Marquee tool ( ) to create a rectangular selection as shown.

**2** Click the Quick Mask Mode button ( ) at the bottom of the Toolbox to enter Quick Mask mode. The areas outside the selection are colored red.

**3** Use the Brush tool ( ) to paint the areas of the background that should not be included in the selection. You may need to zoom in ( ) to paint more accurately.

**4** Use the Eraser tool ( ) to remove the red mask from areas of the woman that should be included in the selection.

**5** The goal is to have everything except the woman highlighted in red. The red masked areas indicate parts of the image that won't be selected.

**6** When you're finished, click the Standard Mode button ( ) at the bottom of the Toolbox. The woman should now be selected, as shown here.

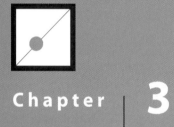

Chapter | **3**

# Basic Editing Skills

Whether you are creating images for print or for use in Web pages, it is important to develop skills that allow you complete control over your graphics. These skills include moving, cropping, resizing, and transforming. In this chapter we'll cover these basic skills so that you'll have a solid foundation for more advanced Photoshop techniques.

# Basic Tools and Commands

In this chapter, you will learn about the Move, Crop, and Slice tools. You will also learn how to transform an image and resize both the image and the image canvas. This chapter also includes some useful exercises that will allow you to practice these skills.

## The Move Tool

The Move tool (⊞) is at the top of the Toolbox. Use this tool to move a guide or selected parts of an image. If you have another tool selected, you can still use the Move tool temporarily by holding down the Ctrl key. The mouse pointer will change shape to let you know that the Move tool is active. It will remain active until you release the Ctrl key.

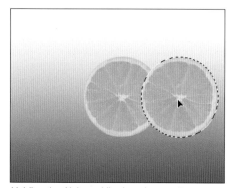

Holding the Alt key while dragging creates a copy of the selection.

Dragging the selection to another image window makes a copy in the new window.

## Options Bar of the Move Tool

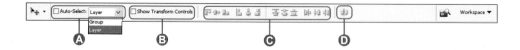

### **A** Auto Select

- **Layer:** When this option is checked, you can drag an image without first selecting its layer. If this option is not checked, you have to select the layer (from the Layers palette) containing the image first. Alternatively, holding down the Ctrl key while clicking a layer in the image window will automatically select the layer when the Auto Select Layer option is turned off.

- **Groups:** When you check this option and use the Move tool, the layers within a group are moved as a unit. This option is only available when Auto Select Layer is checked.

### **B** Show Transform Controls

When this option is selected, a bounding box containing eight adjustable points appears around the image. The points can be dragged to transform the image. This is similar to using Edit > Free Transform (Ctrl-T). You will learn about the Free Transform command later in this chapter.

### **C** Layer Alignment

The Layer Alignment option automatically lines up layers. The option is used when there are two or more linked layers within the image.

### **D** Auto-Align layers

Align the layer image by using the Projection command in the Auto-align Layers dialog box.

## The Crop Tool

The Crop tool ( ) is used to cut out a portion of an image. When you crop an image, you create a smaller image based on your crop selection. Use the Crop tool to select an area to crop. The Crop border will contain eight adjustment points that you can use to move, resize, or rotate the crop area. To complete the crop, press Enter. Pressing Esc will undo the crop selection.

Select the area to crop.

Press Enter to crop the image.

tip >>

**An Alternate Crop Method**

You can also use the Selection tool to create a selection, then choose Image > Crop.

## Options Bar of the Crop Tool

The Crop tool Options bar before a crop selection is made

**Ⓐ Width and Height:** Sets the width and height of the crop area.

**Ⓑ Resolution:** Sets the crop resolution.

**Ⓒ Front Image:** Click to automatically set the size and resolution to that of the front image.

**Ⓓ Clear:** Clears the entered values.

The Crop tool Options bar after a crop selection is made

**Ⓐ Cropped Area:** Select Delete to remove areas outside of the crop area completely; choose Hide to hide unwanted areas from view. Hidden areas can be recovered by choosing Image > Reveal All.

**Ⓑ Shield Color:** Indicates the areas that are outside of the crop area.

**Ⓒ Opacity:** Sets the opacity of the color indicating the cropped area.

**Ⓓ Perspective:** Check this option to use the adjustment points to give the image perspective.

## Changing the Image Size

Each image appears on an image canvas. You can use Image > Image Size to change the size of the image and canvas at the same time. This command can also be used to change the resolution of the image.

Resizing the image to a smaller size

Original image

## The Image Size Dialog Box

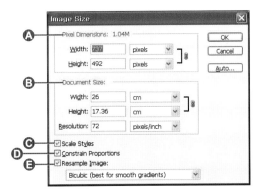

**A** **Pixel Dimensions:** Displays the width and height of the current image.

**B** **Document Size:** Displays the print size and resolution.

**C** **Scale Styles:** When this option is checked, style effects are scaled with the image.

**D** **Constrain Proportions:** When this option is checked, the ratio of the width to the height is kept constant as you resize the image.

**E** **Resample Image:** If you select the Resample Image option, the dimensions of the image will remain the same regardless of changes made to the resolution (and vice versa). In other words, Photoshop will add or remove pixels so that your image is the same size regardless of its resolution. Without this option selected, the total number of pixels will remain constant, and changes made to the Resolution value will increase or decrease the width and height measurements of your image accordingly. Note that selecting this option and altering the resolution will affect the file size of your image.

## Changing the Canvas Size

The size of the canvas can be changed without affecting the size of the image by using the Image > Canvas Size command. If you reduce the size of the canvas, you will be warned that the image will be cropped. If you increase the canvas size, the additional area will be filled with the background color.

Reducing the canvas size

Original image

Increasing the canvas size

# The Canvas Size Dialog Box

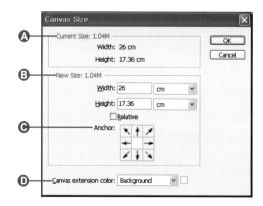

**Ⓐ Current Size:** Displays the file size, width, and height values for the current image.

**Ⓑ New Size:** Used to set the new size of the canvas.

**Ⓒ Anchor:** The white square represents the position of the image on the canvas. Click on one of the squares in the grid to anchor the image at that position. This will change how space is added or removed when you change the canvas size. In this case, additional space will be added equally to all sides of the image.

**Ⓓ Canvas extension color:** Determines the color used to extend the document background.

## The Slice and Slice Select Tools

The Slice tool ([icon]) divides images intended for the Web into smaller sections. You can create a separate file for each section or slice. It is common to divide a large Web image into slices to reduce downloading time. Once all the image slices display in the Web page, they combine to recreate the original image.

You can create slices by dragging the Slice tool over the image. This adds guides for each slice. Save the slices using the File > Save for Web command. Each slice is saved with its own format and filename. The Slice Select tool ([icon]) is used to move or adjust the size of the slices. You can hold down the Ctrl key to toggle between the Slice and Slice Select tools.

Dragging the Slice tool to create slices

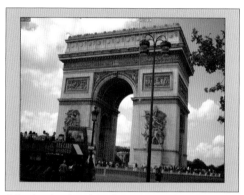

Adjusting the size of the slice using the Slice Select tool

## Options Bar of the Slice Tool

**A** **Style:** Style determines how the slices will be created.
*Normal:* Slice proportions are set by dragging the tool.
*Fixed Aspect Ratio:* Creates slices with a fixed ratio of width to height.
*Fixed Size:* Allows you to specify the height and width of the slice.

**B** **Slices From Guides:** Creates slices from any existing guides within the image.

## Options Bar of the Slice Select Tool

Ⓐ **Slice Order Buttons:** Changes the order of the slices.

Ⓑ **Promote:** Converts from Auto Slice mode to the editable User Slice mode.

Ⓒ **Divide:** Divides the image into the specified number of horizontal and vertical slices.

Ⓓ **Align and Distribute Options:** Used to align and distribute the created slices.

Ⓔ **Hide Auto Slice:** Hides the guide lines in Auto Slice mode.

Ⓕ **Option:** Sets the filename, URL, Target, Message Text, Alt Tag, slice coordinates, and size of the sliced image.

## The Transform and Free Transform Commands

The Edit > Transform and Edit > Free Transform commands on the menu bar let you apply transformations by creating a bounding box that you can adjust around an image. The Free Transform command can also be accessed with the shortcut Ctrl-T.

Whichever way you create a bounding box, you can use it to apply one or more transformations, such as rotation, scale, skew, distort, and perspective. You can also move the image by dragging inside the box.

After you've adjusted a bounding box, you must press the Enter key to apply the changes and transform the image. You can press Esc to ignore the changes you have made and revert the image to its original state.

Ⓐ **Rotation Point:** Clicking and dragging the mouse outside the adjustable points will allow you to rotate the image.

Ⓑ **Center Point:** This is the center point for rotation or size adjustments. Click and drag to move the center point to another location in the layer.

Ⓒ **Width Adjustment Points:** You can use the width adjustment points to increase or decrease the width of an image. Dragging the point inside the image beyond the center point will flip the image.

Ⓓ **Size Adjustment Points:** Clicking and dragging the mouse on the size adjustment points will allow you to adjust the size of the image. Hold down Shift as you drag a corner handle to scale the image proportionately.

Ⓔ **Height Adjustment Points:** You can use the height adjustment points to increase or decrease the height of an image. Dragging the point inside the image beyond the center point will flip the image.

# Exercise 01

## Blending Pictures

In this exercise you will blend a picture of a person with a vacation picture so that it seems like the picture was taken on location. The example uses the Magic Wand tool and the Inverse option.

Final image

```
Start Files
    \Sample\Chapter03\Paris.jpg
    \Sample\Chapter03\Lady.jpg
```

```
Final File
    \Sample\Chapter03\Paris_end.psd
```

**1** Open \Sample\Chapter03\Lady.jpg and Paris.jpg. Select the Magic Wand tool ( ), set the Tolerance to 32, and check Anti-aliased. Click the background of the Lady.jpg image.

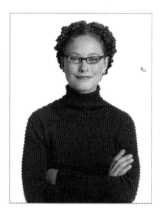

tip >>

### Resource Files

Remember to copy the resource files on the CD-ROM to your hard drive before you start each exercise in this book.

tip >>

### Using the Inverse Selection Command

Where you have a simple background, it is much easier to select the background and invert the selection.

**2** Choose Select > Inverse to invert the selection. The image of the woman will now be selected.

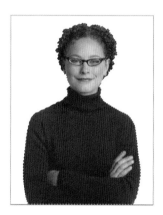

**3** Use the Move tool ( ) to drag the selection to the Paris.jpg image.

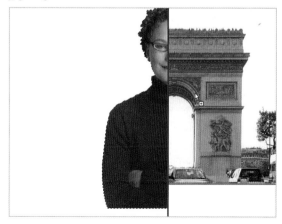

65

**4** The image of the woman is too large compared with the background. Choose Edit > Free Transform to create a bounding box around the image, then drag the corners to reduce the size. Press Enter to apply the transformation.

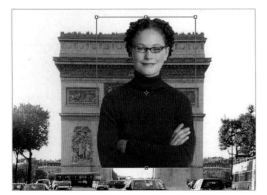

**5** Use the Move tool (⬚) to position the woman on the lower-left side of the Paris.jpg image. The composition of the image is complete, but the lighting looks different because the picture of the woman was taken inside whereas the background image was taken outdoors. This problem can be corrected using the Auto Levels command.

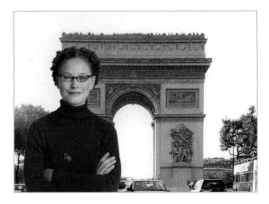

tip >>

**Using the Shift Key**

Hold down the Shift key while resizing the image to maintain the height and width proportions.

**6** Choose Image > Adjustments > Auto Levels. The dark areas will appear darker while the light areas appear lighter. You will learn more about Auto Levels in Chapter 9.

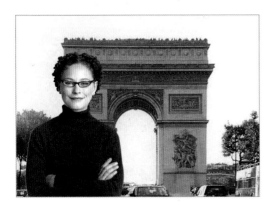

tip >>

**Undoing the Defringe Command**

Sometimes a value of 1 pixel doesn't completely remove the border around an image. In this case, press Ctrl-Z to undo the command, then increase the Width in the Defringe Dialog box.

**7** There is an obvious white border around the woman. This can be removed by choosing Layer > Matting > Defringe and setting the Width to 1. Click OK to remove the white border.

**8** The white border has been removed. Compare your finished image to the completed image\Sample\Chapter03\Paris_end. psd.

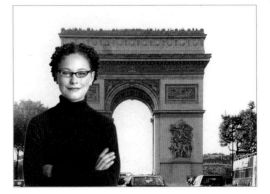

# Straightening an Angled Image Using the Crop Tool

Let's straighten an angled image using the Crop Tool and then transform it into a uniformly colored image through color correction.

Final image

Start Files
\Sample\Chapter03\sign.jpg

Final File
\Sample\Chapter03\sign_end.psd

**1** Open the sign.jpg image file using the Open command. Select the Crop Tool by clicking the Crop Tool button ( ), then drag along the area in which you wish to cut.

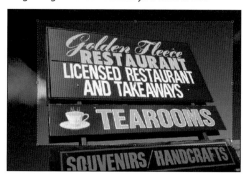

**2** Click on the [Perspective] option from the Crop Tool's option bar. Then maneuver the adjustment points of the Crop Tool to match the outline of the object in the image.

**3** The selected area will straighten itself out once you press the Enter key or double-click within the selected area.

tip >>

**If you cannot move the Adjustment Point**

The option setting of the Crop tool is different depending on whether an area to be cropped is selected or not. The [Perspective] option appears after an area to be cropped is selected. Once the [Perspective] option is checked, you can then maneuver the Adjustment Point.

**4** Choose Layer > New Adjustment Layer > Curves by the from. Once a new New Adjustment Layer appears, click OK.

**5** Alter the curve by dragging on the line in the Curves dialog box, then click OK.

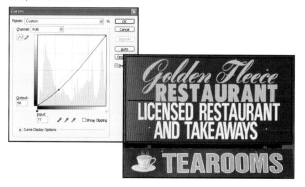

Chapter | **4**

# Painting and Image Editing

Painting tools are frequently used when drawing images in Photoshop, and editing tools allow you to modify your images in countless ways, such as altering tonal balance, saturation, and sharpness. In short, you won't go far in Photoshop without an understanding of these critical tools.

# 01 | The Essentials of Painting and Image Editing

In this chapter, you will learn to paint with brushes and pencils. You'll also explore how to select and use color. Finally, you will learn to use editing tools to blur, sharpen, and smudge an image, as well as change image exposure and color saturation.

## Selecting Color

The Painting tools apply the foreground color to an image, so you should select this color before using the tools. There are many ways to choose colors in Photoshop. You can use the Color Picker, Color palette, and Swatches palette. You can also sample a color from an image using the Eyedropper tool, which is a Color palette option.

### The Color Picker

Click the foreground or background color at the bottom of the Toolbox to bring up the Color Picker dialog box. Choose a color range by dragging the spectrum slide button, and click in the color selection to choose a color. This dialog box shows the RGB, CMYK, and Web hexadecimal color values together. To select Web-safe colors, check the Only Web Colors option.

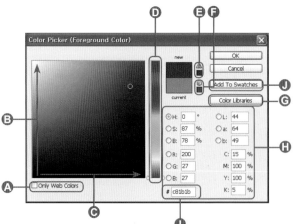

Ⓐ **Only Web Colors:** Restricts the spectrum to Web-safe colors.

Ⓑ **Brightness:** Colors get brighter as this value increases.

Ⓒ **Saturation:** Colors get closer to base colors as this value approaches 100%.

Ⓓ **Hue:** Drag the triangle slider to change the overall spectrum.

**ⓔ Triangular warning icon:** This icon appears if you select a color that isn't print-safe. Click the icon to change to a print-safe color.

**ⓕ Rectangular warning icon:** This icon appears if the selected color is not Web safe. When you click the icon, it changes the selected color to a Web-safe color.

**ⓖ Color Libraries:** Allows you to select colors from Photoshop's color libraries.

**ⓗ HSB, RGB, Lab, CMYK:** Displays the corresponding color values for each color format. You can also enter values to display a specific color.

**ⓘ #:** Shows the hexadecimal color value used in Web pages.

**ⓙ Add To Swatches:** Save the selected color in the swatch palette.

## The Color Palette

To select a color in the Color palette, you can enter a specific color value, drag the sliders, or select a color from the color spectrum bar.

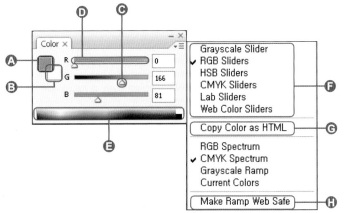

**ⓐ Foreground color:** Shows the current foreground color. When it is selected, click this swatch to open the Color Picker dialog box. If it is not selected, double-click it.

**ⓑ Background color:** Shows the current background color. When it is selected, click this swatch to open the Color Picker dialog box. If it is not selected, double-click it.

**ⓒ Slider:** Select a color either by dragging the sliders or by entering a value.

**ⓓ Channel spectrum bar:** Shows the spectrum available on the corresponding color channel (the channels shown depend on the current color mode).

**ⓔ Color spectrum bar:** When you point at the color spectrum bar, the mouse pointer changes to an eyedropper. Click to sample a color. You can click with the Ctrl key to select a foreground color or use the Alt key for the background color. You can right-click to select a color mode from the shortcut menu. You can also change the color mode by clicking the color spectrum bar with the Shift key held down.

**ⓕ Color modes:** You can choose from six color modes including CMYK and RGB. Your choice depends on the final use for the image.

Ⓖ **Copy Color as HTML:** The color is copied as a hexadecimal number for use in Web pages. You can then paste the hexadecimal value into HTML code.

Ⓗ **Make Ramp Web Safe:** Changes the color spectrum bar so that it only displays Web-safe colors.

## The Swatches Palette

The Swatches palette allows you to select and save frequently used colors. Click a sample color in the palette to set the foreground color in the Toolbox. You can click with the Ctrl key held down to set the background color. To add a color to the Swatches palette, set the foreground color and click in the empty space at the bottom of the Swatches palette. To delete a color swatch, hold down the Alt key and click the sample color. You can load other swatches from the Swatches palette menu or save a new sample set.

## The Brush and Pencil Tools

These tools are used for painting. The Brush tool is used like a paintbrush, whereas the Pencil tool gives a rough edge to drawn lines. Both tools paint with the current foreground color and rely on the size of the brush selected. You can adjust the tool settings in the Options bar.

A picture created with the Brush tool

A picture created with the Pencil tool

## Options Bars of the Brush and Pencil Tools

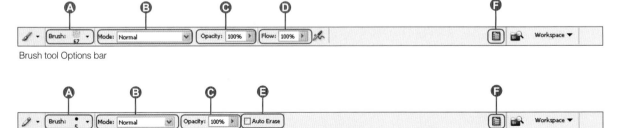

Brush tool Options bar

Pencil tool Options bar

**Ⓐ Brush:** Select the brush or pencil size.

**Ⓑ Mode:** Sets the blend mode used while painting with the Brush and Pencil tools.

**Ⓒ Opacity:** Sets the opacity.

**Ⓓ Flow:** Determines how heavily the color will be applied. The smaller the value, the lighter the painting effect. This option is available only for the Brush tool.

**Ⓔ Auto Erase:** When this option is checked, you can use the tool in the following way. While painting in the foreground color, release the mouse and then paint over the painted area. The new line will be painted in the background color. This option is available only for the Pencil tool.

The image is painted the foreground color.

Click over the foreground color to paint in the background color.

Click over the background color to paint in the foreground color.

**Ⓕ Brushes Palette toggle button:** Shows or hides the Brushes palette.

## The Airbrush Tool                                                Note>>>

In Photoshop 6 and earlier, the Airbrush tool was a standalone tool. Since Photoshop 7, it is an option of the Brush tool. If you select the Airbrush option, the Brush tool works like an aerosol can. Holding down the mouse button will continuously spray color in the image.

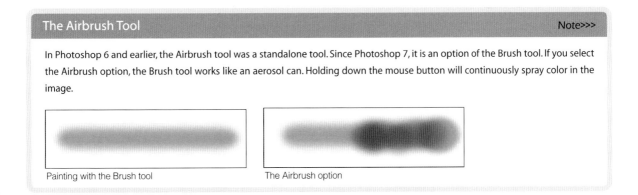

Painting with the Brush tool                    The Airbrush option

## The Brushes Palette

The Brushes palette allows you to select existing brushes or create your own new brushes. You can set brush options such as brush size and shape for the Brush, Pencil, and Eraser tools. When you click the toggle button at the right of the Options bar, the Brushes palette appears. You can select a brush saved in the Brush presets or choose from the Brush Tip Shape list.

## The Brush Presets Dialog Box

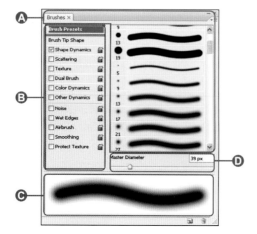

Ⓐ **Brush Presets:** Provides preset options and user-defined brushes.

Ⓑ **Brush Tip Shape:** Provides numerous settings for customizing brushes. See the follow section for additional details.

Ⓒ **Brush preview:** Previews the stroke drawn by the currently selected brush.

Ⓓ **Master diameter:** Sets the size of the brush.

## The Brush Tip Shape Dialog box

Clicking on Brush Tip Shape displays Photoshop's brush customization options.

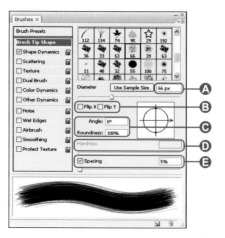

Ⓐ **Diameter:** Sets the thickness of the brush.

Ⓑ **Flip X/Flip Y:** Flips the brush along the X axis or Y axis.

**Ⓒ** **Angle/Roundness:** Sets the angle and roundness of the brush tip. When roundness is 100%, the brush draws a circle, while a setting of 0% draws a straight line.

Roundness: 100%, Angle: 45°

Roundness: 50%, Angle: 45°

**Ⓓ** **Hardness:** Determines the hardness of the brush edges. The edges of the brush smoothen as the number is lowered.

Hardness: 0%

Hardness: 50%

**Ⓔ** **Spacing:** Controls the saturation of the brush; this affects how solid brush strokes are.

Spacing: 1%

Spacing: 100%

Spacing: 150%

Spacing: 200%

## The Fill Tools

The fill tools can be used to fill enclosed areas of a graphic with a color, gradient, or pattern.

## The Paint Bucket Tool

Click the Paint Bucket tool (🪣) to fill an enclosed area with a single color or pattern.

Choose Foreground fill in the Options bar to fill with the foreground color.

When you choose Pattern in the Options bar, the area is filled with the selected pattern.

## Options Bar of the Paint Bucket Tool

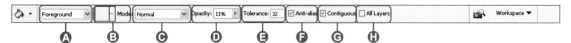

**A** **Foreground/Pattern:** Fills with the foreground color or a pattern.

**B** **Pattern:** Offers patterns to be selected when filling with a pattern.

**C** **Mode:** Determines the blend mode of the applied fill.

**D** **Opacity:** Specifies the opacity for the fill. When this value is high, the color appears opaque. When this value is low, the color appears transparent.

**E** **Tolerance:** Sets the tolerance limit from 0 to 255. The higher this value, the larger the area that will be filled.

**F** **Anti-alias:** Check this option to apply anti-aliasing to reduce jagged edges around the fill.

**G** **Contiguous:** Check this to fill only adjacent areas of similar color.

**H** **All layers:** Check this to apply the fill to all layers, as opposed to only the currently selected layer.

## The Gradient Tool

The Gradient tool (▣) creates a gradual blend of colors. The resulting fill depends on the gradient style, the selected colors, the length of the dragged area, and the angle of the dragged area. The gradient Options bar provides five gradient styles, and you can also create your own gradients.

Drag to apply a gradient within the area to be filled.    The gradient is affected by the direction and length of your mouse drag.

## Options Bar of the Gradient Tool

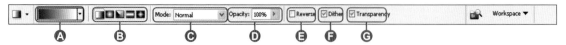

**A** **Gradient preview:** Click the gradient preview to bring up the Gradient Editor dialog box.

**B** **Gradient Style:** By default, there are five options for gradient style, as shown here.

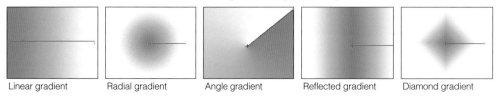

Linear gradient    Radial gradient    Angle gradient    Reflected gradient    Diamond gradient

**ⓒ Mode:** Determines how the gradient will be blended into the image.

**ⓓ Opacity:** Sets the opacity of the gradient.

**ⓔ Reverse:** Reverses the direction of the gradient.

**ⓕ Dither:** Creates a smoother blend of colors with less banding.

**ⓖ Transparency:** If the selected gradient has transparency, check this option to apply that transparency. If the option is not checked, all gradients will appear opaque.

## The Gradient Editor Dialog Box

To open the Gradient Editor dialog box, select the Gradient tool and then go to the Options bar and click inside the gradient preview that appears at the upper left.

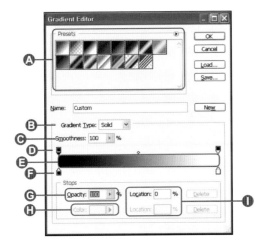

**Ⓐ Presets:** Contains the preset and saved gradients. Click New to create a new gradient.

**Ⓑ Gradient Type:** Choose Solid for smooth color gradients and Noise for line gradations.

**Ⓒ Smoothness:** Sets the smoothness of the gradient.

**Ⓓ Opacity Stop:** Defines the transparency value at a point on the gradient. Click below the gradient bar with an opacity stop selected to create an additional stop. Drag an opacity stop outside of the gradient bar to remove it.

**Ⓔ Gradient bar:** Shows the current gradient.

**Ⓕ Color Stop:** Defines a color point along the gradient. Click below the gradient bar with a color stop selected to create an additional stop. Drag a color stop outside of the gradient bar to remove it.

**Ⓖ Opacity:** Adjusts the opacity of the selected opacity stop. A value of 100% will appear as a solid color.

**Ⓗ Color:** Sets the color of the selected color stop. Double-click to bring up the Color Picker.

**Ⓘ Location:** Sets the position of the selected stop.

## The Blur, Sharpens, and Smudge Tools

The Blur tool (🔘) is used to blur part of an image. If you want to apply a blur to the whole image, use the Gaussian Blur filter instead. You can apply a Gaussian Blur filter by selecting Filter > Blur > Gaussian Blur from the Menu bar.

The Sharpen tool (🔺) is used to sharpen edges or contours within an image. If you want to sharpen an entire image, use the Unsharp Mask filter instead. You can apply an Unsharp Mask filter by selecting Filter > Sharpen > Unsharp Mask from the Menu bar.

Original image

Result of applying the Blur tool

Result of applying the Sharpen tool

tip >>

**Don't Overuse the Sharpen Tool**

Using a high strength setting or applying the Sharpen tool too much will create a rough texture.

The Smudge tool (🖐) extends and transforms pixels to make the image look smudged. This tool can be used to create fire effects or to give the impression of motion. A similar effect can be created using the Liquify filter found in the Filter menu of the Menu bar.

Original image

Result of applying the Smudge tool

tip >>

**Strength and Finger Painting**

The Smudge tool includes a Strength setting that affects how much smudge is applied. The higher the value, the stronger the effect becomes. The Finger Painting option applies the smudge using the foreground color.

## Brightness and Saturation Tools

The Dodge tool (🔆) and the Burn tool (✊) are used to correct over- or underexposure, or to add light and dark effects to an image. The Dodge tool brightens the image, while the Burn tool darkens or adds shadows to the image.

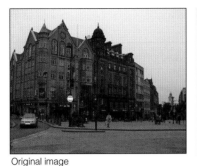
Original image

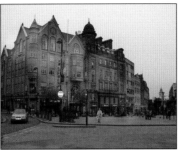
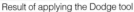
Result of applying the Dodge tool

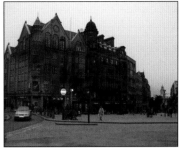
Result of applying the Burn tool

The Sponge tool (🧽) is used to adjust the saturation of color within an image. When the Saturate option is selected in the Options bar, the Sponge adds color. The Desaturate option can be used to remove color.

Result of applying the Sponge tool after setting it to Desaturate

Result of applying the Sponge tool after setting it to Saturate

tip >>

**Range Setting**

The Range option of the Dodge and Burn tools determines where the effect is applied. Choosing Highlights affects the light areas in an image, while Midtones affects the middle tones. Choosing Shadows affects the darker areas of the image. Use higher exposure settings for stronger effects.

## The Eraser Tools

The Eraser, Background Eraser, and Magic Eraser tools all remove parts of an image.

The Eraser tool (🖉) erases part of an image, revealing the background color displayed in the Toolbox. If you're working on a background layer, the Background Eraser tool (🖉) will erase to transparency (which appears as a checkerboard pattern). The Magic Eraser tool (🖉) is similar to the Magic Wand tool and erases colors of a specified range from an image.

The Eraser tool erases to the background color.   The Background Eraser tool erases the background color to transparency.   The Magic Eraser tool erases similar colors according to the Tolerance value.

## Options Bar of the Eraser Tool

**Ⓐ Brush:** Selects a brush shape for the eraser.

**Ⓑ Mode:** Sets the shape of the eraser to Brush, Pencil, or Block.

Brush   Pencil   Block

**Ⓒ Opacity:** Sets the opacity of the eraser from 1% to 100%. When you set the value to 100%, the erased section becomes fully opaque. This option cannot be selected in Block mode.

**Ⓓ Flow:** When using the Airbrush option, sets how deeply the pixels will be erased. The lower the value, the lighter the erasing effect. This option can be only be selected in Brush mode.

**Ⓔ Airbrush:** Hold down the mouse for a continuous erasing effect. This setting can only be used in Brush mode.

**F Erase to History:** Erases the image to a previous state or snapshot in the History palette.

**G Brushes Palette toggle button:** Shows or hides the Brushes palette.

## Options Bar of the Background Eraser Tool

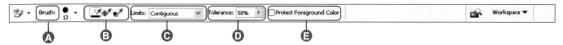

**A Brush:** Selects a brush shape for the eraser.

### B Sampling

*Continuous*: The color to be erased is continually sampled and changed. This is useful if you want to erase colors from an area where there are many different colors.

*Once*: The sample color to erase is set by the first mouse click. This is useful for erasing a single color from the background.

*Background Swatch*: Erases colors that are the same as the current background color.

### C Limits

*Discontiguous*: When you click a color to erase, all areas of the same color are erased even if they are not adjacent.

*Contiguous*: Erases similar colors from adjacent areas.

*Find Edges*: Removes similar colors from adjacent areas, but preserves the object edges between the colors.

**D Tolerance:** Set a Tolerance value from 1% to 100%. A lower value means that only very similar colors will be erased.

**E Protect Foreground Color:** Prevents colors similar to the foreground swatch in the Toolbox from being erased.

tip >>

**Magic Eraser Tool Options Bar**

The Options bar for the Magic Eraser tool is the same as that for the Magic Wand tool, which is explained in Chapter 2.

# 01 Painting a Line Drawing

Final image

In this exercise, we will paint color onto an image composed only of lines. Because all the lines are closed in the sample image, it will be easy to select areas with the Magic Wand tool. We will work on different layers to make it easier to work with the graphic.

Start Files

\Sample\Chapter04\Elf.jpg

Final File

\Sample\Chapter04\Elf_end.jpg

**1** Open the file elf.jpg. Adjust the image window size to fit the full screen by pressing Ctrl-0.

**2** Select and drag the Background layer to the Create a new layer button. The Background copy layer will appear in the Layers palette. At this point, change the layer name to "shape."

tip >>

**Resource Files**

Remember to copy the resource files on the CD-ROM to your hard drive before you start each exercise in this book.

**3** On the shape layer, select the background using the Magic Wand tool and remove it by pressing Delete. Make sure to select the parts of the background between the arms and the torso and delete them as well; you can delete them one by one or hold down the Shift key while selecting, then delete them all together.

■ Now use the Magic Wand tool to select each area of the graphic for painting. First, select the hair, specify R: 250, G: 202, B: 46 in the Color palette, and paint by pressing the Alt-Delete keys.

■ Paint the skin, eyes, clothes, and belt in the same fashion. You will have to add the whites of the eyes by painting over the skin color using the Brush tool.

**Skin** R: 255, G: 222, B: 162

**Eyes** R: 52, G: 207, B: 188

**Clothes** R: 113, G: 224, B: 92

**Belt** R: 102, G: 61, B: 168

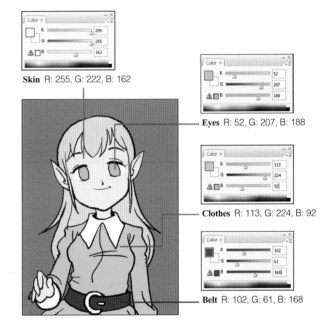

tip >>

### Deselecting

When you are finished working with a particular selection, you should deselect it by pressing Ctrl-D. Throughout this exercise, it's assumed that you will deselect the previous selection before beginning new work.

■ Now we need to add some shading to the image using the Pencil tool (✎). Create a new layer for each shaded area using the note below as a guide. Select an appropriate pencil size and try to draw shading for each layer to match the image above.

■ Create a new layer and name it "effect." We'll use the Brush tool to paint highlights for the hair, face, eyes, and background onto this layer. Use the following RGB values: hair highlights (255, 251, 148), face highlights (252, 177, 148), eye highlights (0, 0, 0), and background snow (255, 255, 255).

■ Save a copy of the file as a separate PSD file so that the layers are preserved for future editing.

■ Now we'll improve the image by applying filters. Choose Flatten Image in the Layers palette pop-up menu so that the filter effects will apply to the whole image.

## Color Values

Note>>>

A. Select the pupils, and create an eyes layer:
   Pupil—RGB: 27, 51, 110
   Effects above and below the pupils—RGB: 255, 255, 255

B. Select the belt and create a belt shade layer:
   RGB: 51, 16, 110

C. Select both parts of the collar and create a collar shade layer:
   RGB: 141, 196, 193

D. Select the hair and create a hair shade layer:
   RGB: 212, 136, 23

E. Select the face, hands, and ears, and create a skin shade layer:
   RGB: 212, 161, 104

F. Select the clothing and create a clothing shade layer:
   RGB: 42, 168, 46

■ Choose Filter > Render > Lighting Effects.

■ Click OK to accept the default settings.

■ The image is final, and you can now save the flattened image in JPG format.

# Using the Gradient Tool to Create a Lomo Camera Image

Images taken with the Lomo camera can have a special touch. The Lomo camera makes the picture bright in the middle and dark in the edges. Let's turn a photo taken with a normal camera into an image that looks as if taken by a Lomo camera.

Final image

Start Files
\Sample\Chapter04\landscape.jpg

Final File
\Sample\Chapter04\landscape_end.psd

■ Open the file landscape.jpg. To make the image file into a reality size, zoom up to 100% of the screen by pressing Alt-Ctrl-O.

■ Click the Create a New Layer button under the Layer palette to create a new layer.

■ Select the Gradient tool (▦) in the Toolbox, and click the Gradient Editor in the option bar to open the Gradient Editor. Select the Black, White gradient in the gradient dialog box and click OK.

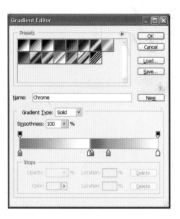

■ Click the Radial Gradient in the gradient option bar, and apply the gradient by dragging to the lower right side from the center of the image.

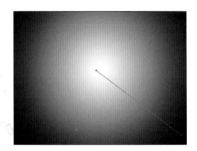

tip >>

**Reverse**

If the gradient is not applied as shown in the picture, check the Reverse option on the option bar.

■ Set the blending mode of the new layer in the Layers palette, to which the gradient is applied, to Multiply. Input 45% as the setting value of Opacity.

■ Add another Layer to the Layers palette and select the Gradient tool again. Apply the Black, White gradient as you did previously in step 3.

■ Set the blending mode of the new layer in the Layers palette to Overlay and input 20% as the Opacity value to complete the image.

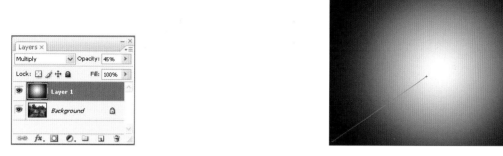

# Creating a Unique Photo Using the Gradient Map

By using the gradient map, you can fill in the gradient colors according to the brightness value of the bright part, regardless of the original color of the image. Let's create a gradient image using the gradient map without using the Gradient tool.

Final image

Start Files
\Sample\Chapter04\woman.jpg

Final File
\Sample\Chapter04\woman_end.jpg

■ Open the woman.jpg file. To make the image file into a reality size, zoom up to 100% of the screen by pressing Alt-Ctrl-O.

■ Choose Image > Adjustments. Select the Gradient Map, which was previously hidden.

■ When the Gradient Map dialog box appears, click the gradient's bar part to select the gradient to be applied to the image.

tip >>

**Gradient Bar**

The gradient bar appears differently depending on the foreground and background colors which are selected from the Toolbox.

■ Click and select the Violet and Orange colors in the Gradient Editor dialog box. You can preview the image. Select the color to be applied to the image and click OK.

■ When Violet and Orange are applied to the image, click OK once more. The gradient is applied to the image. The color of the gradient applied to the image differs depending on the selected gradient.

Chapter | **5**

# Retouching Images

Digital camera owners will find Photoshop's image retouching tools among its most useful features. In earlier versions of Photoshop, the Clone Stamp tool provided the only option for retouching images. However, newer versions of Photoshop include the Spot Healing Brush, Healing Brush, Patch, and Red Eye tools. To get the most out of these tools, it's important to learn how to use them correctly.

# 01

# An Overview of the Retouching Tools

Photoshop's suite of retouching tools is vital to any image editing process. From minor tweaks to whole transformations, virtually anything is possible through some combination of these unique tools. In this section, we'll introduce the range of retouching tools and describe their ideal uses.

## The Correction Tools

In earlier versions of Photoshop, image retouching was carried out only with the Clone Stamp tool. Using this tool required great skill because it merely "painted" an exact copy of another part of the image. (It was necessary to make other adjustments to try to match the image texture in the retouched area.) Using the Healing Brush and Patch tools for image retouching is easier, as both tools automatically match the underlying image qualities. In this section, we'll look at the Healing Brush tool, the Patch tool, and the Red Eye tool.

### The Healing Brush Tool

The Healing Brush tool (🖊) extracts part of an image as a sample and then duplicates it in another area without changing the original shadows, lights, and textures. The sample area is defined by clicking the desired image area with the Alt key held down. Sample areas should be similar in lighting and texture to the area to be retouched. This is a great tool for removing dust, wrinkles, or other marks. See the following example for a demonstration.

1. Hold down the Alt key and click an area of the image where there is no damage. In the image shown here, we will click where there are no wrinkles.

2. Click and drag over the damaged area to paint the sample over it. In this image, the wrinkles have been removed.

## Options Bar of the Healing Brush Tool

**A Brush:** Determines the brush size.

**B Mode:** Determines the blend mode.

**C Source**

*Sampled*: Select the clean source by clicking with the Alt key held down. Retouch the damaged area by dragging with the mouse.

*Pattern*: Dragging the mouse applies the selected pattern while maintaining the original color and texture of the image.

Sampled      Pattern

**D Aligned:** This option allows you to sample pixels continuously. If unchecked, the original sample point will be used.

**E Sample:** You can select Current Layer, Current & Below, or All Layers for the corrected sample image.

## The Spot Healing Brush Tool

The Spot Healing Brush tool (🖌) efficiently corrects small damaged areas within an image, such as dust spots.

1. Start by identifying the damaged part of the image, and select the Spot Healing Brush tool (🖌). This image contains several dust spots.

2. Adjust the brush size to an appropriate diameter, and then simply paint over any problem areas. The tool automatically smooths and blends painted areas to remove imperfections.

## The Patch Tool

The Patch tool (⬚) is similar to the Spot Healing Brush tool, but instead of matching the brush size to the damaged section, you select the problematic area with the Patch tool and drag it to an undamaged area.

1. Select the watch with the Patch tool.

2. Drag the selection to the undamaged area and release the mouse button.

3. The new selection is copied to the original position, and thus the damaged part is filled with the undamaged area. Note that this process applies where you've used the default Source option within the Options bar. If you use the Destination option, select the undamaged section first and then drag it to the damaged part of the image.

## The Red Eye Tool

The Red Eye tool (⬚) allows you to quickly correct the red-eye effect that often occurs when you take a photo with a flash.

1. Identify a red-eye problem in an image. Drag the Red Eye tool to select the area. Photoshop will automatically search within that selected area for the red-eye effect.

2. Adjust the Darken Amount in the Red Eye tool Options bar. Here, it is set to 8%.

3. The red eye will disappear from the image.

## The Clone Stamp and Pattern Stamp Tools

Unlike the Healing Brush and Patch tools, which restore images while automatically matching texture and lighting, the Clone Stamp tool reproduces part of an image without "fixing" these characteristics. The Pattern Stamp tool fills an area with a pattern.

### The Clone Stamp Tool

To use the Clone Stamp tool, hold down the Alt key and click to define the source for the clone. Sources defined with the Clone Stamp tool can then be "painted" into any file that is opened in Photoshop.

1. Hold down the Alt key and click to sample part of the image with the Clone Stamp tool (📌).

2. You can then drag the mouse to paint the sampled part of the image. You can do this within the same image or move the clone to a different image.

### The Pattern Stamp Tool

When using the Pattern Stamp tool, you select a pattern and drag the tool to apply the pattern.

1. To use the Pattern Stamp tool (📌), first select a pattern to use by selecting Edit > Define Pattern from the menu. You can also select a saved pattern. Click or drag the mouse over the image to paint on the pattern.

2. Alternately, select an area with the Rectangular Marquee tool (▭). Make sure that the Feather value is set to 0. Define a pattern by selecting Edit > Define Pattern.

3. Select a saved pattern from the Options bar, and click or drag the mouse.

## Options Bar of the Pattern Stamp Tool

Ⓐ **Brush:** Sets the size of the Pattern Stamp tool.

Ⓑ **Mode:** Sets the blend mode.

Ⓒ **Opacity:** Sets the opacity.

Ⓓ **Flow:** Determines the "thickness" of the pattern as you paint.

Ⓔ **Airbrush:** Selecting this option provides a continuous flow of the pattern when you hold down the mouse button.

Ⓕ **Pattern:** Select a pattern.

Ⓖ **Aligned:** Clones the image or pattern in complete repetitions. When this option is not checked, each time the mouse is clicked, the cloning starts from the beginning of the source pattern.

Ⓗ **Impressionist:** Creates an impressionistic clone.

Ⓘ **Brushes Palette toggle button:** Shows or hides the Brushes palette.

## The History Brush and Art History Brush Tools

The History Brush and Art History Brush tools are used to restore an edited image to an earlier state. To use these tools, you have to set a restoration point by taking a snapshot first (basically, this is like placing a bookmark at some stage of your editing process). Note that you can't restore an image after a resolution or color mode change. Also, it's best to use these tools in combination with the History palette.

### The History Brush Tool

To use the History Brush tool, you need to first set a restoration point in the History palette by taking a snapshot of the image. Select New Snapshot from the History palette's pop-up menu to store a snapshot of the current image. You will then be able to selectively restore the image to this point after subsequent editing.

The modified image

Making partial restorations with the History Brush tool

### The Art History Brush Tool

As with the History Brush tool, you use this tool by first setting a restoration point using a snapshot of the image. Next, use the Art History Brush to add artistic touches (see the next page for the available options) while restoring part of the image.

The modified image

The effect created by using the Art History Brush

# Options Bar of the Art History Brush Tool

**Ⓐ Brush:** Sets the size of the brush.

**Ⓑ Mode:** Sets the blend mode.

**Ⓒ Opacity:** Sets the opacity.

**Ⓓ Style:** Offers artistic styles for the brush.

Tight short    Tight medium    Tight long

Loose medium    Dab    Tight curl

Tight curl long    Loose curl    Loose curl long

**Ⓔ Area:** Defines the area to which the tool will be applied. The larger the value, the larger the brush area.

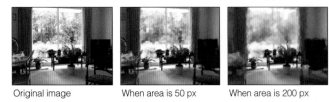

Original image    When area is 50 px    When area is 200 px

**Ⓕ Tolerance:** Higher Tolerance values limit paint strokes to areas that differ considerably from the colors in the snapshot.

**Ⓖ Brushes Palette toggle button:** Shows or hides the Brushes palette.

## The History Palette

The History palette records all the steps that you've taken within a file in Photoshop. You can use it to return to an earlier step in your editing process by selecting the step from the list in the History palette. You can choose the number of steps to retain in the palette by selecting Edit > Preferences > General and specifying a number in the History States setting within the General area. Note that when you take steps beyond the number specified here, the oldest tasks are deleted. As described, you can take a snapshot of an image to preserve a specific state in your image editing process.

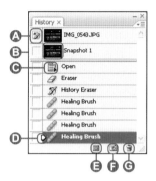

**A** **Source for the History Brush:** Sets the snapshot or image to use with the History Brush or Art History Brush tools.

**B** **Thumbnail of a snapshot:** A snapshot displayed as a thumbnail. Click to select a thumbnail to use with the History Brush tools. You can rename the snapshot by double-clicking it and entering a new name.

**C** **History states:** This list shows the commands that you've used.

**D** **History state slider:** The position of the slider indicates the current step. Drag the slider to return to a previous step. All steps after that point will be overwritten by any new steps if you proceed from the earlier state. If you check the Allow Non-Linear History option in the History Options dialog box, steps will be preserved rather than overwritten.

**E** **Create new document from current state:** A new document is created, which is the same result you would get from choosing Image > Duplicate.

**F** **Create new snapshot:** Creates a snapshot from the current image state.

**G** **Delete current state:** Deletes the most recent step from the History palette.

tip >>

### History Shortcuts

- **Ctrl-Z:** Undoes the last action.
- **Crtl-Shift-Z:** Moves forward one action. Press repeatedly to move forward multiple steps.
- **Alt-Shift-Z:** Moves backward one action. Press repeatedly to move backward through multiple steps.

# Pop-Up Menu of the History Palette

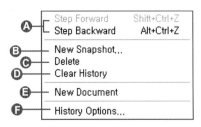

**Ⓐ Step Forward/Backward:** Moves one step forward or backward in the history list.

**Ⓑ New Snapshot:** Creates a new snapshot of the current image. You see each snapshot as a thumbnail in the upper part of the History palette. You can return to a specific snapshot state by clicking it.

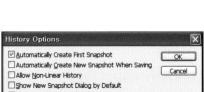

*Full Document*: Saves all layers.

*Merged Layers*: Saves layers merged together.

*Current Layer*: Saves only the current layer.

**Ⓒ Delete:** Deletes the selected history item.

**Ⓓ Clear History:** Clears the steps from the History palette.

**Ⓔ New Document:** Generates a new document from the image in the window.

**Ⓕ History Options**

*Automatically Create First Snapshot*: Automatically saves a snapshot when the image is first opened.

*Automatically Create New Snapshot When Saving*: Automatically creates a snapshot when the image is saved.

*Allow Non-Linear History*: Normally, when you move backward in the History palette, steps that occur after the selected point will be deleted. But when you check this option, all steps will remain in the list, even when you move to an earlier step.

*Show New Snapshot Dialog by Default*: Shows the dialog box when you create a snapshot.

*Make Layer Visibility Changes Undoable*: Check to restrict undoing of layer visibility changes.

---

tip >>

**Specifying History Steps**

You can specify the number of steps to retain by selecting Edit > Preferences> Performance and entering a value in the History States setting. The default value is 20, but you can specify a number between 0 and 1000.

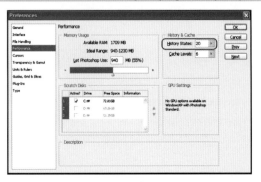

# 01 Removing Fine Lines and Correcting Skin Tone

In this exercise, you will use the Patch tool to remove wrinkles. You will also use the Smudge tool to reshape the face. Finally, you will apply the Gaussian Blur filter and change the blend mode to brighten up the skin tone.

Final image

Start Files
\Sample\Chapter05\Age.jpg

Final File
\Sample\Chapter05\Age_end.psd

**1** Open \Sample \Chapter05 \Age.jpg. Use the Patch tool ()
to select the lines under the eye.

tip >>

**Resource Files**

Remember to copy the resource files on the CD-ROM to your hard drive before you start each exercise in this book.

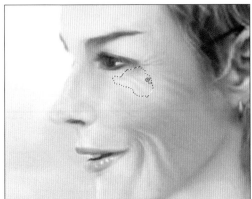

**2** Click inside the selection and drag it to an unlined area of the face. Release the mouse. The lines under the eye will be replaced by the unlined target area.

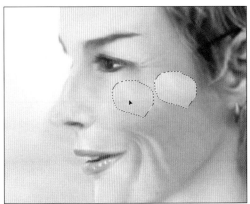

**3** Repeat the steps above to remove other lines from the face.

**4** Select the Smudge tool and set the Brush Size to 80 pixels in the Options bar. Use this tool to drag the skin around the jaw line. You could also use Filter > Liquify to make this adjustment.

**5** Use the Smudge tool ( ) to contour the jaw and the nose. Be careful not to overuse the tool as it will create a blurry image that looks unnatural.

**6** Correct the skin tone by copying the layer. Select Layer > New > Layer via Copy to create Layer 1 in the Layers palette.

**7** Click Layer 1 and choose Filter > Blur > Gaussian Blur. Set the Radius to 5 pixels and click OK. This will blur the overall image and soften the contours of the face.

**8** Set the blend mode of Layer 1 to Screen and the Opacity to 70%. The Screen mode will combine Background and Layer 1 to brighten up the skin tone. The Opacity setting will ensure that the skin tone isn't too bright.

**9** The final image shows a younger-looking face.

# 02

# Applying a Pattern to a Scarf

You can apply a pattern to part of an image. In most cases, you'll use the pattern as a fill on a flat surface. However, there are times when you'll need to apply the pattern to an area that isn't flat. You can achieve a more natural effect using the History palette and opacity settings. In this exercise, we will apply a pattern to a curved and folded scarf.

Final image

Start Files

\Sample\Chapter05\Scarf.jpg
\Sample\Chapter05\Flower_Pattern.psd

Final File

\Sample\Chapter05\Scarf_end.psd

**1** Open the files Scarf.jpg and Flower_Pattern.psd. Select the Rectangular Marquee tool (⬚) and set the Feather value to 0 pixels in the Options bar. Select the flower shape by dragging as shown. Make sure your selection closely matches the flower image so that the repeated pattern doesn't contain too much unpatterned space.

tip >>

### Caution When Registering a Pattern

You must remember to set the Feather value to 0 in the Options bar before you can use the Rectangular Marquee tool to define a pattern. Otherwise, the pattern will have soft edge lines as it repeats in your graphic.

**2** Select Edit > Define Pattern. Enter the name 'Flower' and click OK.

**3** Select the Pattern Stamp tool (🖼) and set the Opacity in the Options bar to 30%. Check Aligned and choose the Flower pattern from the Pattern drop-down menu.

**4** Rather than painting the pattern directly onto the scarf, it will be easier to add it to a new layer. Click the Create a New Layer button ([🔲]) at the bottom of the Layers palette to create Layer 1.

**5** Use the Pattern Stamp tool ([🔳]) to paint the pattern onto the scarf. Drag around the scarf without releasing the mouse button. If you release the mouse, the opacity of the pattern will increase.

**6** Click the Create a New Layer button ([🔲]) at the bottom of the Layers palette to create Layer 2. Set the Opacity to 60%. Drag and paint the scarf again.

**7** Use the Move tool to drag Layer 2 so that the elements of the pattern in the two layers don't overlap.

**8** Drag the History Brush tool ([🖌]) to erase the patterned areas outside of the scarf.

**9** Select the History Brush tool ([🖌]) and set the Opacity to 10% in the Options bar. Drag the History Brush tool over the shadows of the scarf to create a more natural look.

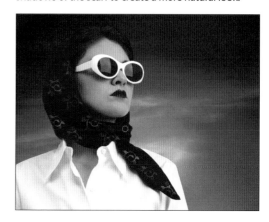

# Using the Art History Brush to Create a Canvas Effect

The History palette contains a record of all the steps carried out on an image. The original image is preserved, as are any snapshots taken of the image. The Art History Brush can be used to restore images to an earlier point and add artistic touches at the same time. In this section, you will use the Art History Brush to create an image that looks like a painting on canvas.

Final image

Start Files
\Sample\Chapter05\Picture.jpg

Final File
\Sample\Chapter05\Picture_end.jpg

**1** Open\Sample\Chapter05\Picture.jpg. Select the Art History Brush tool (  ), click the Brush Preset Size button, and select the Hard Round brush. Leave the other values at their default settings and set the Style to Tight Long.

**2** Drag the brush onto the image and paint the entire image.

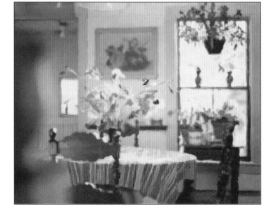

**3** Select New Snapshot from the pop-up menu of the History palette.

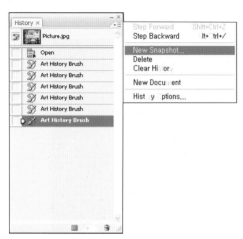

**4** In the New Snapshot dialog box, enter the name 'Picture Snapshot' and click OK.

**5** The History palette shows Picture.jpg and Picture Snapshot in the snapshot list along with their thumbnails.

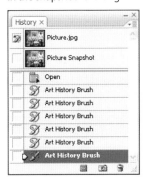

**6** The History palette shows Picture.jpg and Picture Snapshot in the snapshot list along with their thumbnails.

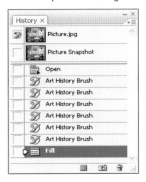

**7** Click the Brushes tab in the Palette Well to activate the Brushes palette. Check that all the options on the left of the palette are not selected and click on Brush Tip Shape. Scroll to select brush 14 as shown here. Set the Diameter to 100.

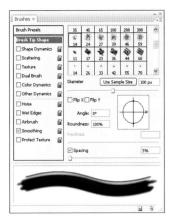

**8** Drag the tool over the white image window to display the Picture Snapshot image.

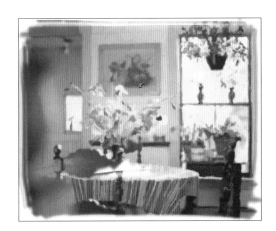

**9** Select Filter > Texture > Texturizer. Set the Texture to Canvas, Scaling to 150, Relief to 5, and the Light Direction to Top Right. Click OK to apply the texture.

**10** The final image is shown above.

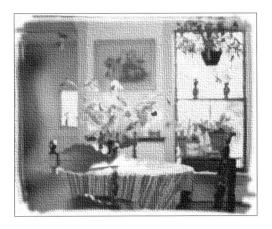

# Giving a Sense of Distance to the Image with the Blurring Effect

The blurring effect can blur parts of the image and give a sense of distance to the image.

Final image

Start Files

\Sample\Chapter05\bag.jpg

Final File

\Sample\Chapter05\bag_end.jpg

**1** Open the bag.jpg file. Select the Round Selection tool (○) from the Toolbox, and drag the center of the image selected while pressing Alt so that the center or focus point of the image becomes the selected part.

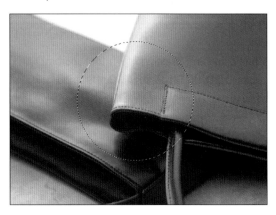

**2** Choose Select > Inverse to reverse the round selected area. Choose Select > Modify > Feather, input 30 as the Feather Radius in the Feather Selection dialog box, and click OK.

**3** Choose Filter > Blur > Gaussian Blur, input 5.5 as the Radius in the Gaussian Blur dialog box, and click OK. Press Ctrl-D to exit the selection mode and cancel the selection.

**4** Select the Blur tool (◌) from the Toolbox, and set the Master Diameter of the brush to 100px.

**5** Drag the edge part of the image where the Feather is applied with the Blur tool and soften around the area. Modify with the Blur tool until the image becomes natural.

Chapter | **6**

# Working with Layers

The layers feature is one of the most critical tools offered by Photoshop. Using layers, you can keep the various graphics and effects that make up an image separate from each other, thus allowing for maximum freedom while making edits. In this chapter, we'll introduce you to the world of layers, and describe some of the ways in which you can use them to edit your images more effectively.

# Getting the Most from Layers

Layers provide an excellent means for organizing and controlling your editing process. They also allow you to make revisions in a non-destructive way. Your options in Photoshop will be limited if you don't separate your graphics into individual layers, so it's crucial that you learn to use layers effectively.

## Layer Basics

The easiest way to think of a layer is to imagine a graphic on a transparent sheet. Multiple sheets (each containing their own graphics) can be stacked to create a larger, more complicated image. Adjusting the order of the sheets can alter the larger image, as different areas of the invidual layers are hidden or shown. Transparency and blend effects can also be applied to determine how the layers interact with each other visually when stacked.

The benefits of using layers in Photoshop should be obvious. By keeping the various 'pieces' of your images separate from each other, you can edit, replace, move, or delete them individually. Photoshop also provides specialized layer types, such as masks and adjustment layers. These layers can be used to edit your images in non-destructive ways.

The complete image

The same image, broken down into its component layers

The image's layers, as shown in the Layers palette

## Understanding the Background Layer          Note>>>

The Background layer is located at the bottom of the Layers palette. This layer has different properties than other layers.

- The Background layer can't be moved; it has to stay at the bottom of the Layers palette.
- The Background layer isn't transparent; it is filled with the background color.
- You can't apply layer styles, change the blend mode, or alter the opacity of the Background layer.
- The Background layer is locked by default, and can't be unlocked.

You can change the Background layer into a normal layer by renaming it (simply double-click its thumbnail in the Layers palette).

Choose the Flatten Image option from the Layers palette pop-up menu to merge all the layers into the Background layer. Since your options for further editing are extremely limited once you've flattened an image, you should only do this once your image is final.

The resulting Background layer

Flattening the Image

# The Layers Palette

You can find many of the options for working with layers in the Layers palette. You'll do most of your work with layers here.

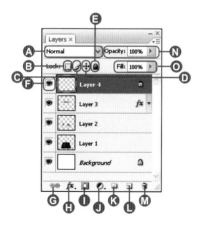

**A** **Blend mode:** Determines how the contents of the selected layer will blend with other layers.

**B** **Lock transparent pixels:** Locks only the transparent areas of the selected layer.

**C** **Lock image pixels:** Locks only the pixel information of the selected layer.

**D** **Lock position:** Locks only the position of the selected layer.

**E** **Lock all:** Locks all aspects of the selected layer to prevent unintended alterations.

**F** **Eye icon:** Click the eye icon to show or hide the selected layer.

**G** **Link layers:** Links selected layers.

**H** **Add a layer style:** Applies a layer style.

tip >>

### Selecting Layers

Select a layer by clicking it in the Layers palette. A selected layer is highlighted in dark blue. Any modifications you make affect only the selected layer.

113

**⬤ Add layer mask:** Converts the selected area in the selected layer into a mask.

**⬤ Create new fill or adjustment layer:** Creates an adjustment layer.

**⬤ Create a new set:** Creates a layer set in which you can store multiple layers.

**⬤ Create a new layer:** Adds a new layer.

**⬤ Delete layer:** Deletes the selected layer.

**⬤ Opacity:** Sets the opacity of the selected layer.

**⬤ Fill:** This applies opacity to the layer's image only while working on the layer that uses layer style.

tip >>

**Layer Groups**

A layer group manages layers in the same way a folder manages multiple files. Layer groups offer a convenient method for grouping layers that are related to each other in some way.

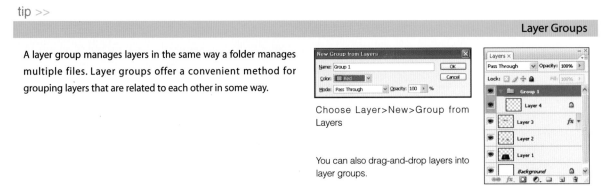

Choose Layer>New>Group from Layers

You can also drag-and-drop layers into layer groups.

## The Layers Palette Pop-Up Menu

The Layers palette pop-up menu is opened from the upper right of the Layers palette.

- **New Layer:** Creates a new layer.

- **Duplicate Layer**: Duplicates the selected layer.

- **Delete Layer**: Deletes the selected layer.

- **Delete Hidden Layers**: Deletes hidden layers.

- **New Group**: Creates a new group folder.

- **New Group from Layers**: Creates a new group from the selected layers.

- **Lock All Layers in Group**: Locks the layers in the selected group.

- **Convert to Smart Object:** Change the image in the selected layer into a smart object.

- **Edit Contents:** Edit a smart object.

- **Layer Properties**: Sets the name and Layers palette color for the selected layer.

- **Blending Options**: Opens the Layer Style dialog box.

- **Create/Release Clipping Mask**: Creates a clipping mask from a linked layer. If a mask layer is currently selected, it releases the mask.

- **Link Layers**: Links the selected layers.

- **Select Linked Layers**: Selects any layers that are linked to the selected layer.

- **Merge Down/Linked**: Merges the selected layer with the layer beneath it in the palette. If the selected layer is linked, the Merge Linked command merges any linked layers.

- **Merge Visible**: Merges visible layers into a single layer.

- **Flatten Image**: Merges all layers into a single layer.

- **Animation Options**: Shows or hides Photoshop's animation options in the Layers palette.

- **Palette Options**: Used to set the size of the thumbnails shown in the palette.

tip >>

**Smart Objects**

A smart object is a container in which you can embed raster or vector image data that retains its original characteristics and remains fully editable. For example, smart objects give you the flexibility to paste or place graphics from Illustrator, then scale, rotate, and warp layers non-destructively in Photoshop. Smart objects are useful because they allow you to perform non-destructive transforms, preserve data that Photoshop doesn't handle natively, and edit one layer to update multiple instances of a smart object.

## The Layer Menu

Open the Layer menu from the Menu bar.

- **New**: Creates a new layer.

- **Duplicate Layer**: Duplicates the selected layer.

- **Delete**: Deletes the selected layer.

- **Layer Properties**: Sets the name and color (in the Layers palette) of the layer.

- **Layer Style**: Applies and edits layer styles.

- **Smart Filter:** Change the image in the selected layer into a smart object. Make the layer to which the Smart Filter is applied hidden, shown, or deleted.

- **New Fill Layer**: Creates a new fill layer—Solid Color, Grandient, or Pattern.

- **New Adjustment Layer**: Creates a wide variety of adjustment layers.

- **Change Layer Content**: Changes the layer content to a different adjustment layer.

- **Layer Content Options**: Modifies an adjustment layer.

- **Layer Mask**: Options relating to a layer mask.

- **Vector Mask**: Options relating to a vector mask.

- **Create Clipping Mask**: Creates a clipping mask from the selected layers.

- **Smart Objects**: Creates a smart objects layer from selected layers.

- **Type**: Edits or converts a type layer.

- **Rasterize**: Creates a pixel-based layer from a vector layer.

- **New Layer Based Slice**: Slices the image according to the selected layer.

- **Group Layers**: Groups selected layers.

- **Ungroup Layers**: Ungroups selected layers.

- **Hide Layers**: Hides selected layers.

- **Arrange**: Arranges the order of layers.

- **Align**: Aligns the positions of layers.

- **Distribute**: Distributes the positions of layers.

- **Lock All Layers in Group (Lock Layers)**: Locks the layers in a group.

- **Link Layers**: Links selected layers.

- **Select Linked Layers**: Selects linked layers.

- **Merge Layers**: Merges selected layers.

- **Merge Visible**: Merges all the visible layers into a single layer.

- **Flatten Image**: Merges all layers into a single layer.

- **Matting**: Softens the layer's edges so they blend with other layers.

## Specialized Layers

Though most layers simply contain graphics, there are several layer types that provide specialized editing functions. We'll review them here.

## Layer Masks

Layer masks cover up part of an image. They use black, white, and the shades of gray in between to determine what to show and what to hide. White areas are transparent while black areas are opaque. Shades of gray represent different levels of transparency.

You can create a layer mask by clicking the Add Layer Mask button (⬚) in the Layers palette.

A layer mask has been applied to this image of a mouse.

Black portions of the mask hide the image. You can see the areas underneath the white and gray sections of the mask.

tip >>

**Removing and Hiding Layer Masks**

To remove a layer mask, drag it to the Delete layer icon (🗑) in the Layers palette. Photoshop will ask whether to apply, cancel, or discard the mask. You can hide a layer mask by holding down the Shift key while clicking the mask's icon in the Layers palette. A red X mark will appear over hidden masks.

## Clipping Masks

A clipping mask can be used to mask the layer above it. This allows you to "cut out" portions of an image using the shape of the layer underneath. You can apply a clipping mask by clicking the border between the two layers (in the Layers palette) while holding the Alt key.

The image produced by a clipping mask

The corresponding clipping mask

## Adjustment Layers

Adjustment layers allow you to edit images in a non-destructive way. Essentially, adjustment layers place your filters and effects on their own layers so you don't have to permanently alter any graphic layers. To create an adjustment layer, click the Create new fill or adjustment layer button ( ) at the bottom of the Layers palette.

Original image

Adding a Hue/Saturation adjustment layer

Image after the adjustment layer is finished

An adjustment layer in the Layers palette

## Shape Layers

Shape layers contain shapes as well as vector content. When you draw a shape, it is made up of paths rather than individual pixels. This allows you to resize shapes without affecting their quality. You can use the Rasterize command to convert a shape layer into a pixel-based layer. Simply select Layer > Rasterize from the Menu bar.

An image with two shape layers

Two shape layers in the Layers palette

## Layer Styles

Layer styles allow you to apply special effects such as shadows, bevels, strokes, and glow effects to layers. You can apply more than one layer style at a time to create more complicated effects. Once you've created a style that you want to reuse, you can save it in the Styles palette.

Original image

Image layers

Image after layer style is applied

Layers palette after a layer style is applied

## The Styles Palette

The Styles palette allows you to apply layer styles easily. You can also edit and load styles from the Styles palette menu.

Ⓐ **Clear style:** Removes an existing layer style from a layer.

Ⓑ **Create new style:** Allows you to save a modified layer style as a new style.

Ⓒ **Delete style:** Deletes a layer style.

Ⓓ **New style:** Creates a new layer style.

Ⓔ **Style display options:** Display as text, as thumbnails, or in a list.

Ⓕ **Preset manager:** Use this to organize preset brushes or palettes.

Ⓖ **Style activation options:** Choose from Reset Styles, Load Styles (from library), Save Styles (to library), or Replace Styles.

# The Layer Style Dialog Box

You can display the Layer Style dialog box by choosing Layer > Layer Style. The dialog box looks complicated but it's actually quite easy to use.

**A** **Styles:** Click here to bring up the palette of preset styles. Select one to apply it to the layer.

**B** **Effects:** Check the box of the effect(s) you'd like to apply. Highlight the effect name to bring up the options specific to that effect.

**C** **Style options:** When no style is selected, this area allows you to adjust the blend or opacity of the layer (see below). When a layer style is selected in the left-hand menu, the options specific to that style appear here.

- General Blending is used to adjust blend modes and opacity.
- Advanced Blending is used to adjust the Fill Opacity, Channels, or Knockout options.
- The slider under Blend If is used to adjust the color range for the selected layer and the layer beneath.

**D** **New Style:** After adjusting the options to your satisfaction, click the New Style button to save the current layer style for future use.

## Drop Shadow

The Drop Shadow style applies a shadow effect to a layer. You can set the color, opacity, angle, and length of the shadow.

**A** **Blend Mode:** Sets the blend mode for shadows. The default mode is "Multiply."

**B** **Opacity:** Sets the opacity for the shadow. The default value is 75%.

**C** **Angle:** Sets the angle of the shadow. The default value is 30°.

**D** **Distance:** Sets the length of the shadow. The default value is 10 pixels.

**E** **Spread:** Sets the spread of the shadow. The default value is 0 pixels. A larger value creates stronger shadows.

**F Size:** Sets the size of the shadow spread. The default value is 5 pixels. Larger values create more blurred edges.

**G Contour:** Sets the curves for the shadow (essentially, this sets the contrast spectrum for the style).

**H Noise:** Adds noise (grain) to the shadow.

**I Layer Knocks Out Drop Shadow:** Determines the visibility of the shadow on a semi-transparent layer.

**J Use Global Light:** Check this to use the same lighting angle applied to other layer styles.

## Inner Shadow

The Inner Shadow option applies a shadow effect inside an image to create a cutout effect.

 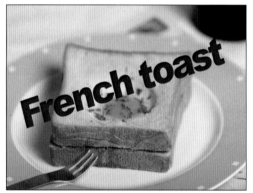

**A Choke:** Set to a higher value to create stronger shadows.

## Outer Glow

The Outer Glow layer style adds a glow around the image.

 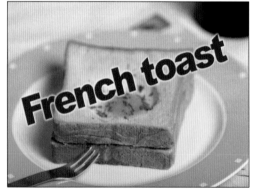

**A Technique:** Determines the spread of light. "Softer" applies soft light and "Precise" applies more sharply defined light.

**B Range:** Sets how the curve contour is applied.

**C Jitter:** Varies the color and opacity of the applied gradient.

## Inner Glow

The Inner Glow layer style adds a glow inside the image. The important option here is Source, which determines the spread of light. Center spreads light from the center outwards. Edge spreads light from the edges towards the center.

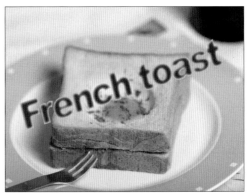

## Bevel and Emboss

This layer style adds three-dimensional effects to an image. There are five styles to choose from.

### Outer Bevel

Chisels outward to create a "sunken" effect.

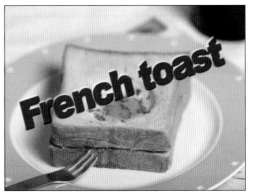

- Ⓐ **Style:** This is where you choose which type of bevel or emboss you want.
- Ⓑ **Technique:** Sets the smoothness of the effect.
- Ⓒ **Depth:** Sets the level of protrusion in the effect.
- Ⓓ **Direction:** Sets the direction for the effect. Choose "Down" to reverse the direction of the highlights and shadows.
- Ⓔ **Size:** Sets the size of the effect.
- Ⓕ **Soften:** Adjusts the softness of the edges.
- Ⓖ **Angle:** Highlights are created in the direction of the angle while shadows appear in the opposite direction.
- Ⓗ **Altitude:** Sets the height of the light.
- Ⓘ **Highlight Mode/Shadow Mode:** Sets the blend mode, color, and opacity of the highlight and shadow.
- Ⓙ **Use Global Light:** Check this to use the same lighting angle applied to other layer styles.
- Ⓚ **Gloss Contour:** This allows to change the external embossing effect.

### Inner Bevel

Chisels the layer inward to create a 3D effect.

 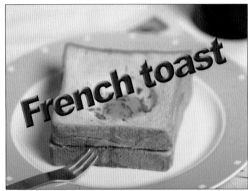

### Emboss

This is like applying both an outer and inner bevel.

 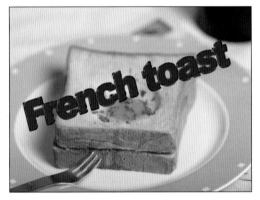

### Pillow Emboss

Adds a bulging effect to the image so that it appears sewn around the edges.

 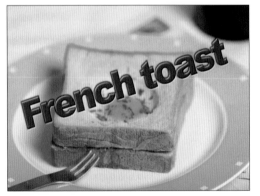

## Stroke Emboss

Applies embossing effects to the edges of an image.

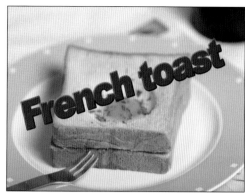

## Contour

This setting applies additional contouring to the bevel/emboss effect.

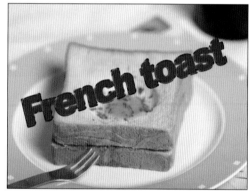

## Texture

Determines texture mapping inside the embossed image.

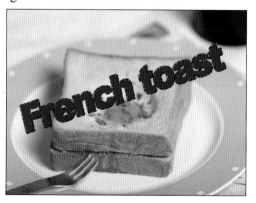

Ⓐ **Pattern:** Applies a preset or customized pattern to the bevel or emboss.

Ⓑ **New Preset:** Saves a customized pattern as a new preset pattern.

Ⓒ **Scale and Depth:** Adjusts the size and depth of the pattern in the texture.

**D Invert:** Flips the texture.

**E Link with Layer:** Specifies that the texture moves with the layer. If this option isn't selected, the texture will shift "inside" the layer when it's moved.

**F Snap to Origin:** Snaps the texture's origin (starting point) with the image if the Link with Layer option is not selected. If the Link with Layer option is selected, this option snaps the texture's origin with the layer's top-left corner.

## Satin

The Satin layer style creates shiny metallic effects.

 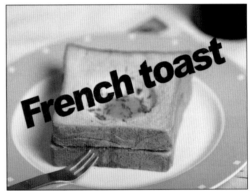

## Color Overlay

This layer style colors the layer with a single color.

 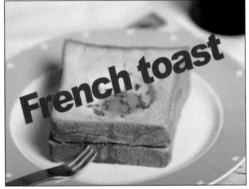

## Gradient Overlay

The Gradient Overlay style fills the layer with a gradient.

## Pattern Overlay

The Pattern Overlay style fills the layer with a pattern.

## Stroke

The Stroke layer style adds a line around the edge of the image using a color, gradient, or pattern.

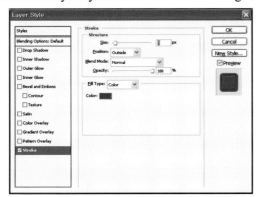 

# Blend Modes

Blend modes determine how the colors in overlapping layers combine to create the final image. You can apply a blend mode to a layer from the top of the Layers palette or the Layer Style dialog box. You can also apply blend modes to several individual tools from their corresponding Options bars.

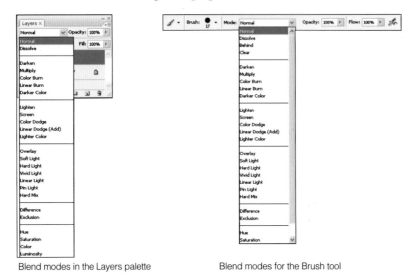

Blend modes in the Layers palette

Blend modes for the Brush tool

Each blend mode creates a different effect, and these are explored in more detail below. The effect of each relies on the base color in the bottom layer as well as the blend color in the layer above. For the following examples, we'll use the layers shown below to demonstrate different blend effects.

Base image

Blended image

Layers palette

tip >>

**Changing Blend Modes Quickly**

You can change blend modes quickly by selecting a blend mode and using the up and down arrow keys on the keyboard.

- **Normal**: The default blend mode. Images stack on top of one another without the colors interacting.

- **Dissolve**: Creates an image made up of random pixels where there is uneven color. This effect is best seen when the Opacity value is less than 100%.

Normal

Dissolve(opacity 75%)

- **Behind**: This mode can only be used on layers that have transparent areas. It allows you to paint onto transparent areas only.
- **Clear**: In this mode, painting creates transparent areas.

Behind

Clear

- **Darken**: Darker colors in the top layer make the image darker.

- **Multiply**: Multiplies the base color by the blend color to create a darker color. White areas remain unchanged.

Darken

Multiply

- **Color Burn**: Increases contrast as if the Burn tool had been used. White areas are unchanged.

- **Linear Burn**: Creates a darkening effect by decreasing brightness. White areas are not changed.

Color Burn

Linear Burn

- **Darker Color:** Leave the dark area and show only the bright parts in the foreground image.

- **Lighten**: Selects the lighter colors from the base and blend layers to create a brighter image.

Darker Color

Lighten

- **Screen**: Multiplies the inverse of the base and blend colors to create brighter colors. The effect is like projecting two slides on top of each other. Black does not affect the image.

- **Color Dodge**: Brightens the area by decreasing the contrast as if the Dodge tool was used.

Screen                    Color Dodge

- **Linear Dodge**: Brightens the area more evenly by increasing the brightness.

- **Lighter Color:** Leave the bright area and show only the dark parts in the foreground image.

Linear Dodge              Lighter Color

- **Overlay**: Multiplies or screens, depending on the colors in the image. This mode does not affect the light and dark areas of the image, but only intensifies the contrast of the saturation and luminosity.

- **Soft Light**: If the color is lighter than 50% gray, the image is darkened as if it were dodged. The effect is like shining a diffuse spotlight on the image.

Overlay                   Soft Light

- **Hard Light**: If the color is lighter than 50% gray, the image is brightened as if it were screened. If the color is darker, the image will appear darker, as if it were multiplied. The effect is like shining a strong spotlight on the image.

- **Vivid Light**: If the color is lighter than 50% gray, the image is lightened by increasing the brightness. The opposite happens for colors darker than 50% gray.

Hard Light                Vivid Light

- **Linear Light**: Hard Light is applied evenly to the whole image.
- **Pin Light**: Hard Light is applied to bright parts of the image.

Linear Light · Pin Light

- **Hard Mix**: Simplifies the colors.
- **Difference**: Subtracts either the blend color from the base color, or the base from the blend, depending on which is brighter. Black produces no change.

Hard Mix · Difference

- **Exclusion**: Similar to Difference mode, but creates a softer effect.
- **Hue**: Creates a color with the luminance and saturation of the lower layer and the hues of the upper layer.

Exclusion · Hue

- **Saturation**: Creates a color with the hues and luminance of the lower layer and the saturation of the upper layer.
- **Color**: Creates a color with the luminance of the lower layer and the hue and saturation of the upper layer.
- **Luminosity**: Creates a color with the hue and saturation of the lower layer and the luminance of the upper layer.

Saturation · Color · Luminosity

**Exercise**

# 01

# Using Layer Blend Modes to Create Luminosity

In this section, we will create a luminous image using layers and blend modes.

Final image

**1** Open the file Princess.psd. This image is already separated into layers. Click the Create a new layer button in the Layers palette. Layer 1 will be added to the palette.

**2** Hold down the Ctrl key and click the black layer to create a selection.

**3** Choose Select > Modify > Feather and set the Feather Radius to 20. Click OK. This will soften the selection.

**4** Set the foreground color to deep blue (C: 100, M: 100, Y: 0, and K: 0), and fill the selection by pressing Alt-Delete.

tip >>

### Resource Files

Remember to copy the resource files on the CD-ROM to your hard drive before you start each exercise in this book.

tip >>

### Preserving Layers

To preserve the layers in an image, you should save your file in Photoshop∗.PSD format.

**5** Hold down the Ctrl key and click the black layer again.

**6** Choose Select > Modfy > Feather and set the Feather Radius to 10. Click OK. The outline of the selection area is softened, but not as much as before.

**7** Select a lighter blue color (C: 50, M: 0, Y: 15, K: 0). Press Alt-Delete to fill the selection.

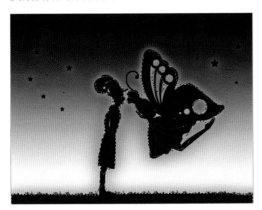

**10** Set the foreground color to white, and fill the selection by pressing Alt-Delete. Press Ctrl-D to cancel the selection.

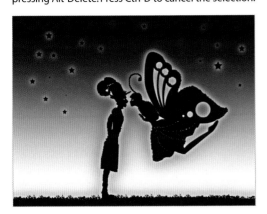

**13** Drag Layer 1 onto the Create a new layer button to create a new layer called Layer 1 copy.

**8** Select Layer 1 again. Hold down the Ctrl key and click the black layer to load the selection.

**9** Choose Select > Feather and set the Feather Radius to 5. Click OK.

**11** Drag Layer 1 onto the Create a new layer button to create a new layer called Layer 1 copy.

**12** Set the blend mode of Layer 1 copy to Overlay and set the Opacity to 50%. This creates contrasting saturation and luminance.

**14** Repeat the same steps on the title layer. Since the title is smaller than the picture, a smaller Feather value will have to be applied. The final image is shown above.

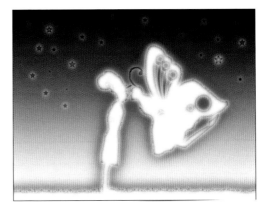

# 02

# Creating a Button Image in a Heart Shape

Let's create pretty button images using a pre-prepared path. You can create various forms and shapes of buttons using the layer, layer effect, and text.

Final image

Start Files
\Sample\Chapter06\heart.jpg

Final File
\Sample\Chapter06\heart_end.jpg

**1** Open the file heart.jpg. Open the Path palette and select the pre-created Path layer. Drag the path with the ( ⚙ ) icon on the Path palette to make it into a selected area.

**2** Click the Create a new layer button on the Layer palette to create a new layer. Set the foreground color in red from the Toolbox, and fill in the foreground color by pressing Alt-Delete. Press Ctrl-D to exit the selected area.

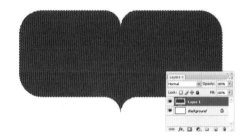

**3** Double-click Layer 1 filled with the red color to open the Layer Style dialog box. Select Bevel and Emboss in Style, enter the values shown, and click OK.

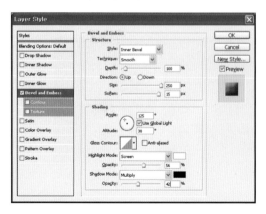

**4** Select the Lasso tool from the Toolbox. Drag as shown in the picture, and create a selected area in the heart shape with the Lasso tool. Select Select > Modify > Feather, enter a value of 2 for the Feather Radius value in the dialog, and click OK.

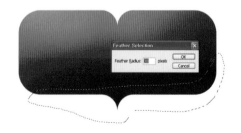

**5** Choose Image > Adjustments > Brightness/Contrast, and click the Use Legacy option in the dialog box. Enter +90 as the value of Brightness, +44 as the Contrast value, and click OK to create a reflected light. Press Ctrl-D to exit the selected area.

**6** Select the Horizontal Text tool from the Toolbox, and set the font as Impact, size as 60pt, Set the anti-aliasing method as smooth. Click the image, input '0602', and move to the center of the image using the Move tool.

**7** Click and turn off the eye icons of the text layer, and create a new layer in the Layer palette. Press and hold Ctrl and click the text layer to make it into a selected area.

**8** Click and select the Gradient Tool from the Toolbox, and change the color of the gradient from light green to yellow in the Gradient Editor. Click OK.

**9** Press Shift and drag downward to fill in the gradient color. Press Ctrl-D to exit the selected area.

**10** Double-click Layer 2 to open the Layer Style dialog box. Click on Inner Shadow in the Layer Style, make the set value as shown below, and press OK.

**11** Open the flower.jpg file. Select the Magic Wand tool in the Toolbox, and click the white part of the floor to make it into a selected area. Make all the remaining parts except the flower into a selected area. Select Select > Inverse to reverse the selected area.

**12** Select the Move tool from the Toolbox to drag and bring the flower.jpg image, which has been made into a selected area, over the image you are currently working with. Move the image to the upper right side and adjust the location. Set the blending mode of adjusted Layer 3 to the Screen, and complete the image.

The Layer Comps palette allows you to save different combinations of the layers in your Layers palette. You may be able to save time by reusing the saved layer arrangements. In this exercise, we'll create a simple layer comp.

① Click Open Flower.psd; this sample file is installed automatically when you install Photoshop CS3 (it's located in the \Adobe\Adobe Photoshop CS3\Samples folder). Click Create New Layer Comp from the Layer Comps tab in the Palette Well. This will save the current image state.

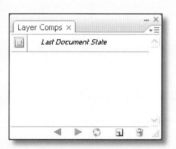

② Make sure that the Visibility, Position, and Appearance checkboxes are checked and click OK to save this as Layer Comp 1.

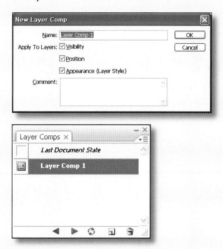

③ After clicking the title layer in the Layers palette, use the Move tool to drag the title image as shown in the figure. Create a new layer comp to save the current image state.

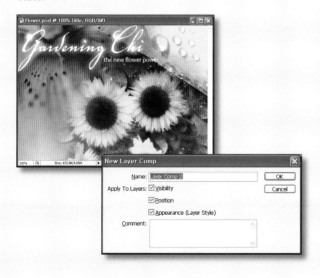

④ Click the Apply Previous Selected Layer Comp button of Layer Comp 1 to show the previous image state. You'll see the original image again.

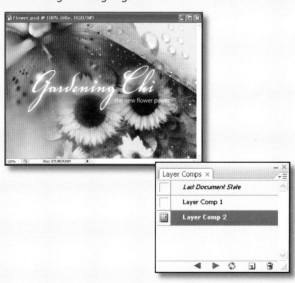

Chapter | **7**

# Paths, Type, and Shapes

You'll primarily work with pixel-based images in Photoshop, as it is designed to produce bitmap files. However, Photoshop does offer numerous tools for dealing with vector-based drawings (i.e., graphics based on lines and shapes instead of individual pixels). Working with vector objects is fundamentally different than manipulating pixels, so we'll devote this chapter to introducing the intriguing world of Photoshop's vector tools.

# Introduction to Vector-Based Editing

Vector images, which are created using paths, are generally simple shapes with clean lines; they are not photo-realistic. However, photo-realism isn't always the goal, so there are many scenarios in which vector tools are preferable to pixel-based options. In this chapter, you'll learn about paths and how to use the vector tools found in Photoshop to create type and draw standard and freeform shapes.

## What Is a Path?

A path is a line consisting of one or more segments connected by anchor points. An anchor point is a point that indicates where the line starts, changes direction, or ends. An anchor also determines the angle of the line passing through it.

Paths display on the screen but don't appear in printed images. They are used as guides in the drawing and editing of images, and can be saved in the Paths palette for repeated use. Uses including clipping paths, defining fill areas, drawing shapes, and much more.

### The Elements of a Path

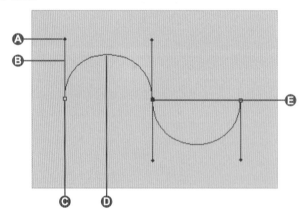

Ⓐ **Direction point:** An endpoint of the direction line, this point is used to adjust the direction line.

Ⓑ **Direction line:** A line used to adjust the shape of the curve by defining the angle at which the line passes through the anchor point.

Ⓒ **Unselected anchor point:** Unselected anchor points appear with a transparent fill.

Ⓓ **Segment:** A line connecting two anchor points.

Ⓔ **Selected anchor point:** Selected points appear with a black fill.

## Working with Paths and Anchor Points

The Pen tool (  ) and the Freeform Pen tool (  ) are used for drawing paths. The Pen tool draws a path in a series of curved or straight line segments, while the Freeform Pen tool draws a path in one continuous stroke.

The Pen tool draws the anchor points that make up a path.

The Freeform Pen tool draws freeform paths.

The Add Anchor Point tool (  ), Delete Anchor Point tool (  ), and Convert Point tool (  ) are used for creating and editing anchor points on a path.

The Add Anchor Point tool adds anchor points to existing paths.

The Delete Anchor Point tool deletes anchor points from existing paths.

The Convert Point tool is used to change points from line points to corner points.

The Path Selection tool (  ) and the Direct Selection tool (  ) are used to select and move paths and anchor points, respectively.

The Path Selection tool selects a path.

The Direct Selection tool selects individual anchor points.

tip >>

### The Magnetic Freeform Pen Tool

If you check the Magnetic option of the Freeform Pen tool, you can turn it into the Magnetic Freeform Pen tool. With this option turned on, the tool automatically makes a path based on areas of contrast within the image. This is similar to the Magnetic Lasso tool.

Using the Magnetic Freeform Pen tool

# Accessing the Anchor Point Tools

When a path and the Pen tool are selected, you can access the tools for working with anchor points in the following ways:

- Place the tool on top of the active path to convert to the Add Anchor Point tool (⊞).
- Place the tool on top of the active anchor point to convert to the Delete Anchor Point tool (⊞).
- Place the tool on top of the active anchor point and press Alt to convert to the Convert Point tool (⊠).
- Place the tool on top of the path and press Ctrl to convert to the Direct Selection tool (⊠).

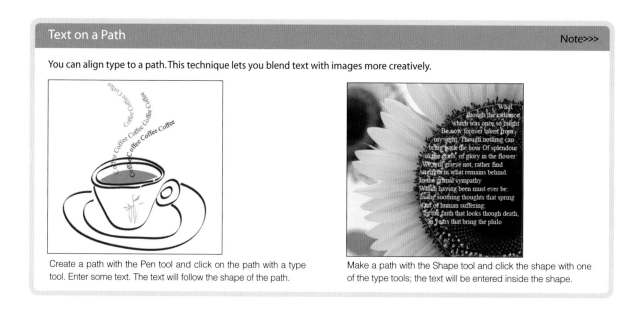

## Text on a Path                                                                    Note>>>

You can align type to a path. This technique lets you blend text with images more creatively.

Create a path with the Pen tool and click on the path with a type tool. Enter some text. The text will follow the shape of the path.

Make a path with the Shape tool and click the shape with one of the type tools; the text will be entered inside the shape.

# Options Bar of the Pen Tool

🅐 **Shape layers:** Creates a layer that contains the path. Styles or effects can be applied to the layer.

Ⓑ **Paths:** Creates a work path in the Paths palette.

Ⓒ **Pen tool selection:** Choose between the Pen tool and the Freeform Pen tool.

Ⓓ **Auto Add/Delete:** If selected, pointing at a path will automatically change the tool to the Add Anchor Point tool. Pointing at an anchor point will change the tool to the Delete Anchor Point tool.

Ⓔ **Path interaction options:** Choose from Create new shape layer, Add to shape area (+), Subtract from shape area (-), Intersect shape areas, and Exclude overlapping shape areas.

Ⓕ **Style:** Click on the link button and select a style.

Ⓖ **Color:** Select the color for the shape layer.

## Showing and Hiding Paths                                    Note>>>

Paths can be used as guides for coloring, outlining, and creating selections. When using paths as guides, you may want to show or hide the paths. This can be done in the Paths palette.

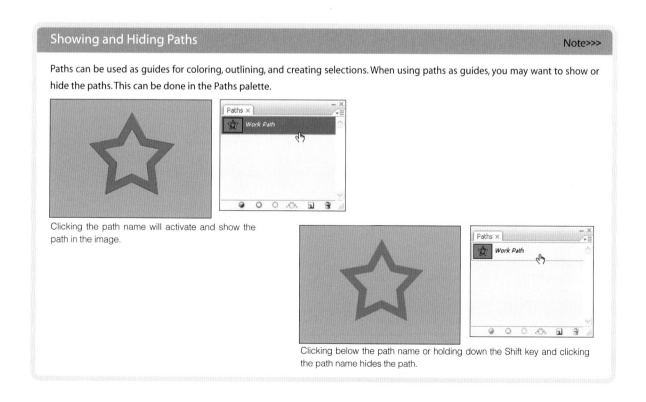

Clicking the path name will activate and show the path in the image.

Clicking below the path name or holding down the Shift key and clicking the path name hides the path.

## The Paths Palette

Ⓐ **Fill path with foreground color:** Fills inside the path using the foreground color.

Ⓑ **Stroke path with brush:** Apply a stroke to the path using the foreground color.

Ⓒ **Load path as a selection:** Creates a selection from the path.

Ⓓ **Make work path from Selection**: Creates a work path from the selection. This option is only available when you've made a selection in the image.

Ⓔ **Create new path:** Creates a new path.

Ⓕ **Delete current path:** Deletes the selected path.

## The Paths Palette Pop-Up Menu

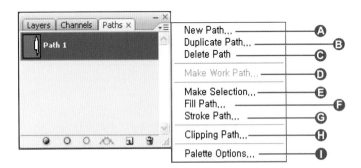

Ⓐ **New Path:** Creates a new path.

Ⓑ **Duplicate Path:** Copies the path.

Ⓒ **Delete Path:** Deletes the path.

Ⓓ **Make Work Path:** Makes a selection into a path.

Ⓔ **Make Selection:** Makes a path into a selection.

Ⓕ **Fill Path:** Fills the path with the foreground color.

Ⓖ **Stroke Path:** Strokes the path with the foreground color.

**H  Clipping Path:** Creates a clipping path.

**I  Palette Options:** Sets the size of thumbnails in the palette.

---

### Clipping Paths
Note>>>

Some page layout programs do not recognize transparency in an image; these programs will print transparent areas as white. To solve this problem, you have to define the transparent and non-transparent areas of an image using clipping paths. The areas outside the path are considered transparent, and those within are visible. This technique is useful for making a background transparent when printed.

In Photoshop, the background is displayed.

When a clipping path is used, the background no longer prints when the image is used in a program such as QuarkXPress or PageMaker.

---

## The Shape Tools

An easy way to create vector objects is to use Photoshop's shape tools, which include the Rectangle, Rounded Rectangle, Ellipse, Polygon, Line, and Custom Shape tools. Photoshop includes a number of preset shapes and you can also save your own shapes. The Direct Selection tool (  ) can be used to modify these shapes once they're drawn in your image.

Each shape tool offers its own set of options available from the universal shape tool Options bar. Access these from the Geometry options pull-down menu in the Options bar.

### The Rectangle, Rounded Rectangle, and Ellipse Tools

Simply click and drag in the image window to draw the shape of the selected tool.

From left: Shapes drawn using the Rectangle tool ( ), Rounded Rectangle tool ( ), and Ellipse tool ( )

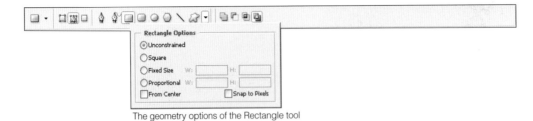

The geometry options of the Rectangle tool

- **Unconstrained**: Creates a freeform shape by dragging.

- **Square**: Creates a square.

- **Fixed Size**: Creates a rectangle using the specitied width and height values.

- **Proportional**: Creates a rectangle using the specified proportions.

- **From Center**: Draws the rectangle from the center outward.

- **Snap to Pixels**: Select this option to snap the boundaries of your rectangles to the image's underlying pixel grid.

tip >>

### Geometry Options of the Rounded Rectangle and Ellipse Tools

The geometry options for the Rectangle, Rounded Rectangle, and Ellipse tools contain similar options, but there are options unique to each tool. In the Rounded Rectangle tool window, you will see the Radius option, which determines the roundness of corners. In the Ellipse tool window, you will see the Circle option, which lets you draw perfect circles.

## The Polygon Tool

Creates a polygon or a star shape.

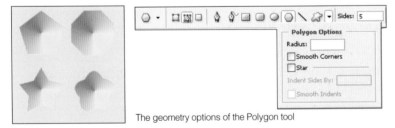

The geometry options of the Polygon tool

- **Radius**: Sets the radius of the shape.

- **Smooth Corners**: Rounds the corners of the polygon.

- **Star**: Select this option to draw a star instead of a polygon.

- **Indent Sides By**: When Star is checked, specifies the indent for the sides.

- **Smooth Indents**: When Star is checked, this option smooths the indented sides.

- **Sides**: Determines the number of sides in the shape.

# The Line Tool

The Line tool is used to draw lines or arrows.

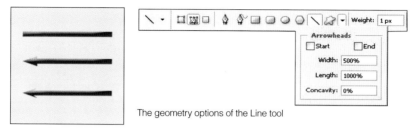

The geometry options of the Line tool

- **Start**: Adds an arrowhead at the start of the line.
- **Width**: Sets the width of the arrow.
- **Length**: Sets the length of the arrow.
- **Concavity**: Determines the arrowhead shape.
- **End**: Adds an arrowhead at the end of the line.
- **Weight**: Sets the thickness of the line.

# The Custom Shape Tool

With the Custom Shape tool, you can create your own shapes or customize a predefined shape.

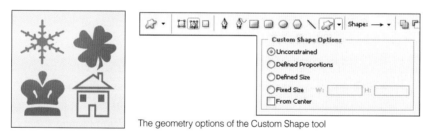

The geometry options of the Custom Shape tool

- **Unconstrained**: Draws the shape in a freeform manner.
- **Defined Proportions**: Draws the shape using the default proportions.
- **Defined Size**: Draws the shape using the default dimensions.
- **Fixed Size**: Draws the shape using the designated size.
- **From Center**: Draws the shape from the center outward.

tip >>

**The Fill Pixels Option**

Selecting the Fill Pixels option (▣), which is available in the Options bars of all the shape tools, lets you create shapes as bitmaps without creating separate paths or layers.

tip >>

The custom shape picker is displayed when the Shape drop-down menu is clicked in the Custom Shape tool Options bar. Click the pop-up menu button at the right to reveal more custom shapes. Choose All to load all the preset shapes.

## The Type Tools

Text is entered as vector objects in Photoshop using one of the four type tools. Regardless of which tool you select, you will need to click the Commit button (✓) to apply the changes to your image.

The Horizontal Type tool (T) and the Vertical Type tool (IT) let you enter text into an image either horizontally or vertically. The text that is entered will be placed on a separate text layer (a text layer is indicated by a letter T in the Layers palette.) Because the text is vector-based, it does not distort when the size of the text is changed. In addition, even after you have entered text, you can still edit it simply by retyping. But if you change a text layer into a normal layer by rasterizing it (Layer > Rasterize > Type), the text cannot be edited, as it is no longer vector-based.

Text entered using the Horizontal Type tool and Vertical Type tool

Using the Horizontal and Vertical Type tools creates a new text layer in the Layers palette. A new text layer is created with each text entry.

tip >>

A vector shape can be converted to a bitmap with the Layer > Rasterize command.

The Horizontal Type Mask tool (▤) and the Vertical Type Mask tool (▤) behave quite differently from the Horizontal/Vertical Type tools. The Horizontal and Vertical Type Mask tools create a text selection in the current layer. These selections can be moved, copied, stroked, and filled.

The Horizontal and Vertical Type Mask tools create a mask to protect areas that will not be edited.

Clicking the Commit button in the Options bar turns the entered text into a selection.

## Options Bar of the Type Tool

**Ⓐ Change the text orientation:** Changes horizontal text to vertical and vice versa.

**Ⓑ Font family:** Selects the font.

**Ⓒ Font style:** Depending on the selected font, options may include Normal, Italic, Bold, or Bold Italic.

**Ⓓ Font size:** Sets the text size.

**Ⓔ Anti-aliasing method:** Used to determine the smoothness of the letter shapes.

*None*: No change.
*Sharp*: Roughened edges.
*Crisp*: Edges are turned inwards.
*Strong*: Strong edges.
*Smooth*: Smooth edges.

**Ⓕ Text alignment:** Select left, center, or right alignment.

**Ⓖ Text color:** Sets the text color.

**Ⓗ Create warped text:** Warp the text in different styles.

**Ⓘ Toggle Character and Paragraph palettes:** Shows or hides the Character and Paragraph palettes.

## The Warp Text Dialog Box

Click the Create Warped Text button (  ) in the Options bar of the Type tool to display the Warp Text dialog box. This allows you to warp text in various styles. You can't warp text that has been rasterized or that has "faux bold" applied from the pop-up menu of the Character palette.

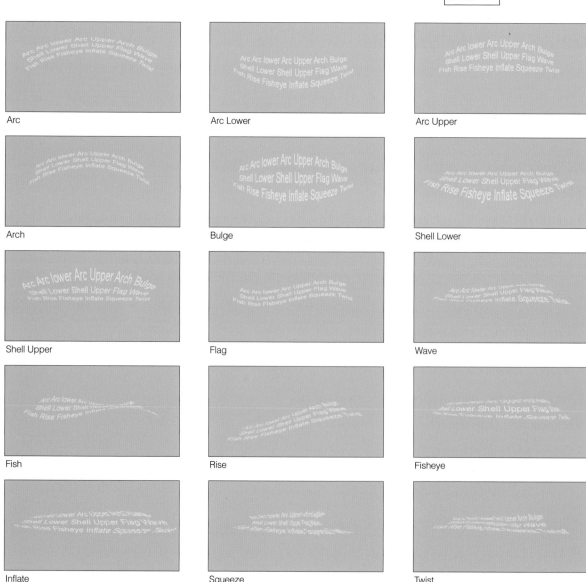

Arc

Arc Lower

Arc Upper

Arch

Bulge

Shell Lower

Shell Upper

Flag

Wave

Fish

Rise

Fisheye

Inflate

Squeeze

Twist

# The Character Palette

The Character palette provides options for formatting characters. Some formatting options are also available in the Options bar. Display the Character palette by selecting Window > Character.

**Ⓐ** Choose the font.

**Ⓑ** Choose the type size.

**Ⓒ** Set the kerning (a formula-based method for determining letter-by-letter character spacing).

**Ⓓ** Set the vertical scale of the font.

**Ⓔ** Adjust the baseline.

**Ⓕ** Select Language.

**Ⓖ** Select Anti-Aliasing.

**Ⓗ** Font style.

**Ⓘ** Adjust leading (the vertical space between lines of text).

**Ⓙ** Adjust tracking (determines the overall spacing between letters).

**Ⓚ** Adjust the horizontal scale of the font.

**Ⓛ** Choose the color.

**Ⓐ Faux Bold:** Makes letters appear bold.

**Ⓑ Faux Italic:** Makes letters appear italicized.

**Ⓒ All Caps:** Uses all capital letters.

**Ⓓ Small Caps:** Uses small capital letters.

**Ⓔ Superscript:** Creates superscript (raised) letters.

**Ⓕ Subscript:** Creates subscript (lowered) letters.

**Ⓖ Underline:** Adds an underline.

**Ⓗ Strikethrough:** Adds a line through the text.

# The Paragraph Palette

You use the Paragraph palette to change the formatting of columns and paragraphs. To display the palette, choose Window > Paragraph from the Menu bar.

**Ⓐ** Paragraph alignment and justification options

**Ⓑ** Specify left indent

**Ⓒ** Specify first line indent

**Ⓓ** Add space above paragraph

**Ⓔ** Specify hyphenate

**Ⓕ** Specify right indent

**Ⓖ** Add space below paragraph

# Using Paths to Frame Pictures

Paths can be used for many different purposes, so it is important to become comfortable with using the Pen tool to draw straight, curved, and freeform lines. In this section, you will learn to create selections with paths. You will also learn how to work with the Pen tool, which can take a little practice to master.

Final image

Start Files
\Sample\Chapter07\Frame.jpg
\Sample\Chapter07\Frame2.jpg

Final File
\Sample\Chapter07\Frame_end.psd

tip >>

**Resource Files**

Remember to copy the resource files on the CD-ROM to your hard drive before you start each exercise in this book.

**1** Open Frame.jpg. Select the Pen tool ( ) from the Toolbox and click on the second of the three path style buttons in the Options bar. Click the starting point as shown.

**2** Click on the next point as shown above. A line segment will appear connecting the two points. Continue in this fashion until you have drawn around the star, down, and over to the curved section of the moon.

**3** In order to draw a curved path, click to add a new anchor point and drag away from the anchor point to create a curve. Two direction lines for the path will appear as you drag.

**4** The next segment that needs to be drawn is at a sharp angle from your last anchor point. You cannot simply click for your next point because the resulting line will be at the wrong angle. You will first need to convert the anchor point to a corner point in order to draw a path at a sharp angle. Hold down the Alt key and click on the anchor point when you see this icon ( ▶ ).

**6** Hold down the Alt key and click on the anchor point when you see this icon ( ▶ ) to turn the anchor point into a corner point. Click and drag out a new anchor point to create a curved segment for the top of the moon. Hold down the Alt key and click on the new anchor point you created to turn it into a corner point. Then, click on the center of the starting point to complete the path.

**8** Click Load path as a selection at the bottom of the Paths palette. A selection will be created along the path.

**5** Click the tool on the bridge of the nose, then click and drag the mouse to the tip of the moon. This will create a curved line. Move the mouse until the curve fits the moon's crescent shape, as shown.

**7** In the Paths palette, a path called Work Path has been created. Select Save Path from the pop-up menu and save the path as "frame."

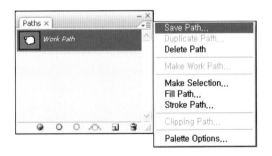

**9** Open file Frame2.jpg. Choose Select > All to select the entire image and use Ctrl-C to copy the image to the clipboard.

**11** Click the Add a layer style button in the Layers palette. Select Inner Shadow from the menu to add a shadow inside the frame.

**13** Shadows have been added to the framed image, giving it a more realistic look. The image has been completed.

**10** Click Frame.jpg and select Edit > Paste Into to paste the image inside the selection (shortcut keys: Shift-Ctrl-V).

**12** The Inner Shadow option will be activated automatically in the Layer Style dialog box. Click OK to apply the style using the default settings.

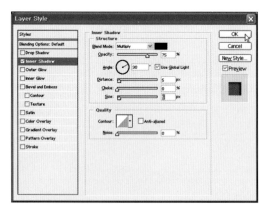

Final image

The previous example showed you how to create a path and use it for a selection. In this exercise, you'll apply different brush strokes to saved paths to make neon and fireworks effects.

Start Files
\Sample\Chapter07\festival.jpg

Final File
\Sample\Chapter07\festival_end.jpg

tip >>

**Brush Size Shortcut Keys**

You can change the brush size using your keyboard: press [to increase the brush size, and press] to reduce the brush size.

**1** Open festival.jpg. Click the Create a new layer button in the Layers palette. Double-click the layer name and enter "glow".

**2** Choose the Brush tool (  ) from the Toolbox and select the brush preset Soft Round 45 pixels. Set the Opacity to 20%.

**3** In the Color palette, set the foreground color to R: 70, G: 185, B: 240.

**4** In the Paths palette, drag-and-drop the festival path onto the Stroke path with brush button at the bottom. You could also have clicked the festival path to activate it, then clicked on the button. The brush has now traced a line around the path.

**5** From the brush picker pull-down menu in the Options bar, change the Master Diameter for the Brush tool to 30. Set the Opacity to 40%. In the Paths palette, drag-and-drop the festival path onto the Stroke path with brush button.

**6** Another line is created using a smaller brush and a darker color. This creates a smudged effect. Press the [ key two times to reduce the brush size to 10, then change the Opacity to 60%. In the Paths palette, drag-and-drop the festival path onto the Stroke path with brush button.

**7** Set the foreground color to white and press the [ key five times to reduce the brush size to 5. Change the Opacity to 100%. In the Paths palette, drag-and-drop the festival path onto the Stroke path with brush button.

**8** In the Layers palette, drag-and-drop the glow layer onto the Create a new layer button to create the layer "glow copy." Drag the glow copy layer below the glow layer and set the blend mode to Overlay.

**9** Select Filter > Blur > Gaussian Blur. Set the Radius to 30 and click OK.

**10** Select the Ellipse tool (⬭) from the Toolbox and, in the Options bar, click on the Paths button (▨). Hold down the Shift key and drag the tool in the image window to make several circles.

**11** The Paths palette shows circular paths. Save the paths by double-clicking Work Path and entering the name "spark."

**12** In the Layers palette, press the Ceate a new layer button to create a layer. Double-click the layer name and enter the name "spark."

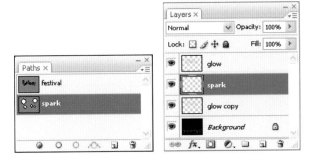

**13** Select the Brush tool (🖌) and click the Brush tab in the Palette Well to open the Brushes palette. Click Brush Tip Shape and choose Star 33 Pixels from the list on the right. Set the Diameter to 33 and the Spacing to 100.

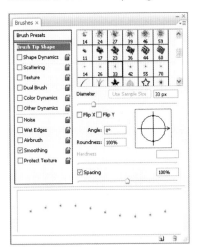

**14** Click Shape Dynamics and set the Size Jitter to 100%.

**15** Click Shape Dynamics and set the Size Jitter to 100%.

**16** Set the foreground color to pink and drag-and-drop the spark path onto the Stroke path with brush button in the Paths palette. This will create an outline around the circles.

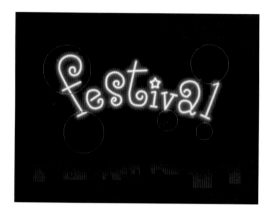

**17** Change the foreground color and drag-and-drop the spark path onto the Stroke path with brush button in the Paths palette. You may want to repeat this step with different colors to complete the image.

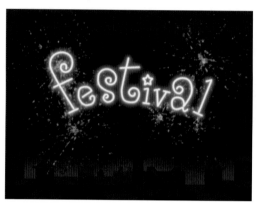

# Inserting an Image over a Torn Sheet of Paper

Let's correct the color of the dark image and create a synthesized image by inserting the image over a white sheet of paper.

Final image

Start Files
\Sample\Chapter07\paper.jpg, grapes.jpg

Final File
\Sample\Chapter07\paper_end.jpg

**1** Open the paper.jpg and grapes.jpg files. Click and open the paper.jpg file, and click the Create new adjustment layer button on the Layer palette to select Levels.

**2** Enter values of 20, 1.13, 204, in that order, for the Input Levels in the Levels dialog box (or move each slider to set its value) and click OK.

**3** Select the Pen tool from the Toolbox and select the Pen tool option as the path in the option bar. Use the Pen tool to make the path along the outline of the rumpled paper.

**4** By selecting the Paths palette, you can see that the Work Paths has been automatically created. Enter the name of the path in the Save Paths dialog box, which appears when you double-click Work Paths, and click OK. Drag the Load path as a selection button at the lower part of the Paths palette, and make it into a selected area.

**5** Select the grapes.jpg file, and select the Move tool from the Toolbox. Press and hold down Shift and drag over the paper. jpg file, with which you are currently working; you can bring the image to the center of the image.

**6** Click the Add layer mask button of the Layers palette, making the image in the selected area into a mask, and completing the image work.

# 04

# Creating Transparent Images for the Web

In this exercise, we will make the background of an image transparent so that the background color of the Web page it's placed on shows through. There are many ways to create a transparent background. Here, we will use the Pen tool to create a transparent background and save it as a GIF Web image using Save for Web.

Final image

┌ Start Files
└ \Sample\Chapter07\guitarist.jpg

┌ Final File
└ \Sample\Chapter07\
   Webbrowser_end.jpg

**1** Open the file guitarist.jpg in Photoshop.

tip >>

**Workspace Shortcuts**

Change to Full Screen mode before starting work. Pressing the F key will cycle through the modes. Also, the shortcut key for hiding the Palette Well is the Tab key.

**2** Press the shortcut key P to select the Pen tool.

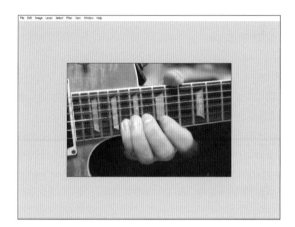

**3** The upper and lower parts of the background aren't contiguous, so we'll have to create two separate paths. Start by selecting the upper part. To create a more accurate selection, start outside of the window. Make sure you join the end point to the starting point.

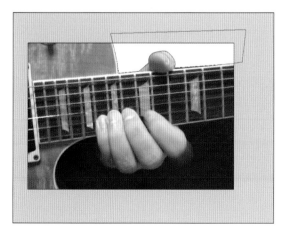

**4** First, select Shape 1 Vector Mask from the Paths palette. Then click on Save Paths from the palette pop-up menu and save as "Path 1".

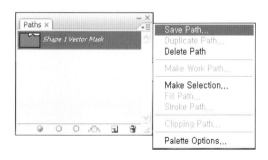

159

**5** Select the lower part of the image with the Pen tool as shown above and save this as "Path 2".

**Undoing Path Mistakes**

If you make a mistake while drawing your path, simply use the Undo command to back up a step.

**7** Select Path 1 in the Paths palette and click the Load path as a selection button. Then, select the Background copy layer from the Layers palette and remove the selected area with the Delete key on the keyboard. Repeat this step for Path 2. In this way, you can create a completely transparent background. Release the selection by pressing Ctrl-D. To save the layers of the image, save the image as a PSD file.

**6** Go to the Layers palette and copy the Background layer. The image is duplicated as a new layer sitting over the Background layer. In this way, you can preserve the original image, and use it as a backup in case the edited version is damaged. To see what you have done so far, you have to turn off the eye icon for the Background layer.

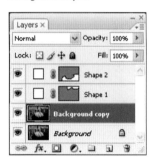

**8** Now, let's make the image viewable in a Web browser. Select File > Save for Web and Devices.

**9** When the dialog box appears, select the Image Size palette and change the Width from 1024 to 320. The Height will be automatically changed to 213. Click the Apply button to apply the change.

**10** The altered image is displayed in the preview window.

**11** When you click the Preview button (), you can see the image in a Web browser.

**12** Click the Save button to open the Save Optimized As dialog box, then save your Web-optimized graphic to your desired location.

Chapter | **8**

# Channels

Channels contain information about colors and selections within an image. There are three kinds of channels in photoshop: color channels manage color within a image, spot color channels manage specialized colors for printing, and alpha channels are used to store and load selections. In this chapter we'll introduce some of the advanced techniques that come into play when working with channels.

# Layers of a Different Sort

Channels are similar to layers, only they contain image-related data rather than pixels or vector shapes. In a way, channels contain the inner workings" of your images. As a result, channels offer numerous methods by which you can fundamentally alter the makeup of your graphics. In this chapter, we'll introduce the different kinds of channels and tell you what you can do with them.

## Color Channels

All images can be split into one or more color channels. The number and type of color channels depends on the color mode of the image. For instance, if the image is in RGB mode, it will contain red, green, and blue channels, as well as a channel for the combined colors. Each channel contains 8 bits of information; when combined, the RGB image has 24 bits (8 bits for each of the three channels), and 16,700,000 colors can be displayed on the screen. Furthermore, each channel stores color, hue, brightness, and shadow information, and you can see and manage the channels in the Channels palette.

Naturally, the color channels are different for each of Photoshop's color modes. The channels for each mode are provided below for reference. (In each case, the first channel is a composite of all the color channels.)

- **Grayscale**: Gray
- **Indexed Color**: Index
- **RGB Color**: RGB, Red, Green, Blue
- **CMYK Color**: CYMK, Cyan, Magenta, Yellow, Black
- **Lab Color**: Lab, Lightness, A, B

### The RGB Channel

We'll continue using the RGB Color mode to demonstrate some common color channel characteristics. The combined color channel, in this case the RGB channel, is the combination of the Red, Green, and Blue channels. In the Channels palette, clicking the RGB channel will select all three color channels and the image will be displayed in full color.

The RGB channel

Selecting the RGB channel in the RGB Color mode displays the image in full color.

# The Red, Green, and Blue Channels

The Red, Green, and Blue channels contain information about their respective colors within an image. By default, selecting any one of these channels in the Channels palette displays the image in grayscale. The white portion represents the areas that contain the selected channel color, while the black portion represents the areas that do not. Displaying an image in this manner makes it easy for you to work on a particular color. You can use a painting tool and paint in white to add the selected channel color, or paint in black to do the opposite.

Selecting the Red channel displays the image in black and white. The white portion represents the red areas while the black portion represents the areas that contain no red.

tip >>

**Showing Colors in the Channels Palette**

When you select a color channel, the image from that channel displays in grayscale. You can set it to display in the appropriate color by choosing Edit > Preferences > Interface and checking the Color Channels in Color option.

## Spot Channels

Spot channels contain information about spot colors. To understand spot colors, you need to understand the CMYK color mode and how colors print. In Chapter 1, you learned about the RGB and CMYK color modes. You learned that when you edit a color image in Photoshop, it's best to work in RGB mode (your monitor is based on the RGB color scheme, so RGB images are ideally suited to be viewed on your screen). You also learned that if your image is to be sent to a professional printer, the color mode must be changed to CMYK prior to the submission of your files.

Printed colors are created using the four process inks: cyan, magenta, yellow, and black. Although cyan, magenta, and yellow can theoretically create black, the impurities in the inks will most likely create a deep grayish hue, hence the need for black ink. Before an image is printed, cyan, magenta, yellow, and black color plates have to be created. Each of these plates determines the area in which a specific color ink will be printed.

A spot color, however, is a matched or exact color that is not printed using the four process inks. A spot color is a color chosen from a color-matching system such as PANTONE. To use a PANTONE spot color, for example, you choose the spot color from PANTONE's color book, which shows you exactly how the color will look when printed. To print a spot color, a spot channel has to be created so that the printer can create a color plate for that specific color.

Spot colors are used to ensure color consistency (for example, to make sure that a company logo appears in the same color on all printed materials). Spot colors are also used to specify metallic colors, which require special inks. For images with fewer than four colors, using spot colors will reduce the cost of printing. For example, you will only need green and black color plates if the image has only green hues.

A spot color channel within the Channels palette

Applying the spot color channel to an image

## Alpha Channels

You learned earlier how to create selections using the selection tools. When you save a selection, it is stored as an alpha channel. Working with alpha channels means that it's possible to edit selections with almost any of the tools and filters in Photoshop.

You can think of an alpha channel as a type of mask. Masks protect parts of an image; alpha channels reveal hidden and partially hidden parts of an image. Alpha channels can show 256 shades of black, white, and gray. Each time you create a new alpha channel, it is named Alpha 1, Alpha 2, and so on.

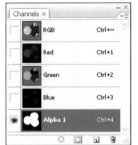

An alpha channel in the Channels palette

Alpha channel

tip >>

**Channels and File Size**

Photoshop can store up to 56 channels in an image. The more channels there are, the larger the file size will be. A CMYK file will be larger than an RGB file as it contains four channels rather than three.

# The Channels Palette

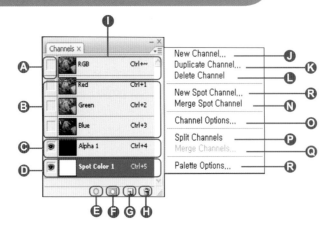

**Ⓐ Eye icon:** Hides or shows the corresponding channel.

**Ⓑ Red, Green, and Blue color channels:** These channels separate the color information in the image according to the color mode (in this case, RGB).

**Ⓒ Alpha channel:** Alpha channels are used to save selection areas. Once saved, they appear in the Channels palette as shown.

**Ⓓ Spot channel:** Spot channels show image information for spot colors.

**Ⓔ Load channel as selection:** Creates a selection based on the channel you have chosen.

**Ⓕ Save selection as channel:** Saves the current selection as a channel. This option is available only when a selection is made in the image.

**Ⓖ Create new channel:** Creates a new channel. An existing channel can be dragged and dropped onto this button to create a copy.

**Ⓗ Delete current channel:** Deletes the selected channel.

**Ⓘ Combined color channel:** Shows all the colors combined (in this case, RGB).

**Ⓙ New channel:** Creates a new channel.

**Ⓚ Duplicate channel:** Copies the selected channel.

**Ⓛ Delete channel:** Deletes the selected channel.

**Ⓜ New spot channel:** Creates a new spot channel.

**Ⓝ Merge spot channel:** Combines the spot channel with the color channel.

**Ⓞ Channel options:** Opens the Channel Options dialog box.

**Ⓟ Split channels:** Splits the channel into separate images.

**Ⓠ Merge channels:** Combines the split channels.

**Ⓡ Palette options:** Adjusts the size of the preview image in the Channels palette.

## The Channel Options Dialog Box                                    Note>>>

Clicking on Channel Options in the Channels palette's pop-up menu opens the Channel Options dialog box. This option is only available when the image contains a spot color or alpha channel.

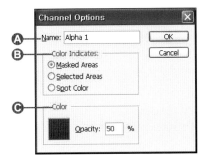

Ⓐ **Name:** The channel name.

Ⓑ **Color Indicates:** Tells you what the color in the channel represents. There are three options.

   *Masked Areas:* The masked areas will be displayed.

   *Selected Areas:* The selected areas will be displayed.

   *Spot Color:* The color indicates where spot color will be applied.

Ⓒ **Color:** Double-clicking the color window displays the Color picker, which can be used to change the mask color.

# Applying Color to Black and White Photos by Modifying the Color Channel

Final image

Let's make a color image into a black and white image and modify the channel to make it into an image with unique colors.

Start Files
\Sample\Chapter08\building.jpg

Final File
\Sample\Chapter08\building_end.jpg

**1** Open the building.jpg file. To make the image into a black and white photo, choose Images > Adjustments > Desaturate.

**2** Select the Channels palette, and select the Red channel. The whole image turns red.

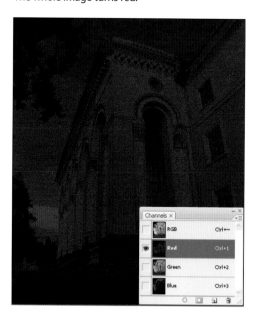

tip >>

**Show Channels in color Option**

If the channel image does not show in different colors as shown in the picture, check the Edit > Preference > Interface > Show channels in color option.

**3** To express colors in the Red channel, choose Filter > Artistic > Cutout. Set the value of the filter that simplifies paper as if cut, and click OK.

**4** Click the RGB channel on the top part of the Channels palette; the simple black and white image changes into a reddish image, becoming unique.

Final image

Let's make old and rusty images using the alpha channel and Calculations.

Start Files
\Sample\Chapter08\rust.psd

Final File
\Sample\Chapter08\rust_end.psd

**1** Open the rust.psd file. Click the Channels palette to drag the pre-created text alpha channel over the Create new channel, making a copy.

**2** Choose Filter > Blur > Gaussian Blur, enter a value of 5 for Radius, and click OK.

**3** Selecting the text copy channel to which Blur is applied, choose Filter > Artistic > Dry Brush, and apply the option values as shown in the picture. Click OK.

**4** Choose Image > Adjustment > Levels, enter the values of 118, 1.00, 120 for Input Levels, and click OK.

**5** Make the foreground color black and the background color white from the Toolbox. Click and select the bg channel in the Channels palette. Choose Image > Adjustments > Levels, and enter values of 124, 1.00, 194 for Input Levels to modify the image.

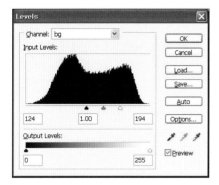 

**6** Select the text copy channel, choose Image > Calculations, and select text copy as the Channel part of Source 1 and bg as the Channel part of Source 2 in the dialog box. Select New Channel as the Result, and click OK.

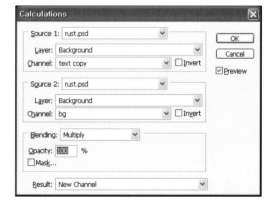

**7** Select the bg channel, and choose Image > Adjustments > Invert to reverse the channel image. Select the text copy channel again, choose Image > Calculations, and specify the Channel part of Source 1 and Source 2 in the dialog box as text copy and bg, respectively. Specify Result as New Channel, and click OK to create Alpha 2.

 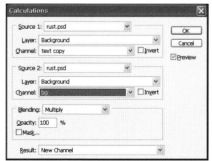

**8** Click the Alpha 1 channel while pressing Ctrl to create a selected area. Click the Layers palette and copy by pressing Ctrl-C with the Background selected. Press Ctrl-V to attach the copied image; Layer 1 is newly created.

**9** Double-click Layer 1, select Inner Shadow in the Layer Effect, and apply the option values as shown in the picture.

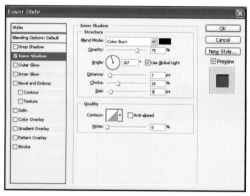

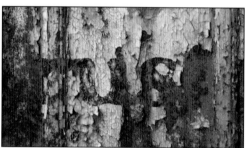

**10** Select Bevel and Emboss as Layer Effect. Apply the Outer Bevel with Down as the Direction.

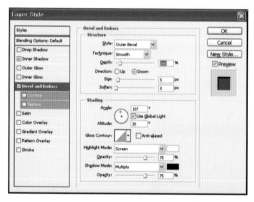

**11** Click Alpha 2 channel while pressing Ctrl to make it into a selected area. Select the Background in the Layers palette, copy by pressing Ctrl-C, and create Layer 2 by pressing Ctrl-V.

**12** Right-click Layer 1, to which the Layer Effect is applied, and select Copy Layer Style in the pull-down menu.

**13** Right-click Layer 2 and select click Paste Layer Style in the pull-down menu to complete the image.

**Chapter** | **9**

# Color Correction

In this chapter, we'll review the various ways in which you can manipulate color in your images. Photoshop provides numerous tools for correcting the color and overall look of photographs and graphics. Possible image adjustments include compensating for over- or underexposure, manipulating brightness and contrast values, and changing the range of tones that are present in an image. These effects are achieved through menu commands such as Levels, Curves, and Variations. In the following pages, we'll introduce color correction procedures to ensure that you have total control over your final images.

# 01

# Color Correction Options

The Image > Adjustments menu contains a number of submenus designed specifically for color correction. These include adjustments for color balance, hue, saturation, brightness, contrast, and tonal range. This chapter covers the Histogram palette and all the commands on the Adjustments menu that are useful for color correction.

## The Histogram Palette

A histogram illustrates how pixels in an image are distributed by graphing the number of pixels at each color intensity level. The Histogram palette maps the tonal information of an image in a histogram. If the pixels of an image are concentrated in the shadows (on the left of the histogram), the image has more dark areas than light ones. An image with a full tonal range will have a histogram that is evenly distributed. To open the Histogram palette, choose Window > Histogram. By default, the Histogram palette opens in Compact View with no controls or statistics, but you can adjust the view from the Histogram palette pop-up menu.

Histogram palette with Compact View

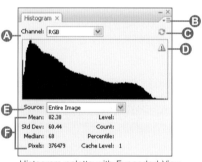

Histogram palette with Expanded View and Show Statistics selected

Ⓐ **Channel:** Select RGB to view the tonal range of the entire image, or select one of the color channels to view only a specific color s tonal range.

Ⓑ **Palette menu:** You can choose viewing options from this menu.

Ⓒ **Uncached Refresh button:** Refresh the histogram to reflect recent edits to the image.

Ⓓ **Cached Data Warning icon:** Appears when the histogram is not current with the image. Click the icon to refresh the histogram

Ⓔ **Source:** Select the source for the histogram data: Entire Image, Selected Layer, or Adjustment Composite.

Ⓕ **Statistics:** Show statistics data of image.

*Mean*: The average image brightness. The larger the mean value, the brighter the image.

*Std Dev*: Indicates the standard deviation, which shows how the tonal values are distributed with respect to the mean. The smaller this value, the more evenly distributed the shadows are.

*Median*: Indicates the color at the middle of the image s tonal range.

*Pixels*: Indicates the total number of pixels in the image.

*Cache Level*: A cache is a memory allotment that enables the computer to execute instructions or retrieve data more quickly than when it uses conventional memory. The Cache Level indicates the image cache used to create the histogram. At Cache Level 1, all the pixels in the image are used to create the histogram. The number of pixels used decreases by three-quarters with every increase to the Cache Level value.

*Percentile*: When you mouse over a point on the histogram, the Percentile field shows you the percentage of pixels in the image that are of the same shade or darker than the selected point.

*Count*: Indicates the number of pixels at the selected point on the histogram.

*Level*: Indicates tonal value at the selected point on the histogram, ranging from 0 to 256.

**Accessing Color Correction Commands**　　　　　　　　　　　　　　　　　　　Note>>>

You can access the image correction features discussed in the following sections by choosing Image > Adjustments.

## The Levels Command

While the Histogram palette is used to review the image s tonal range, the Levels command (Ctrl-L) is used for color correction. The command is often used to correct tonal range, brightness, and contrast.

## The Levels Dialog Box

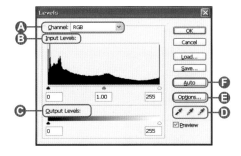

**Ⓐ Channel:** Select RGB to modify the tonal range of the entire image, or select one of the color channels to modify only a specific color s tonal range.

**Ⓑ Input Levels:** Adjusts brightness and contrast. (See the note that follows for additional details.)

**ⓒ Output Levels:** Adjusts the tonal range of the entire image. At its default setting (0/255) the full possible tonal range is "in play." (See the note that follows for additional details.)

**ⓓ Eyedroppers:** Eyedroppers are used to set the black, white, and gray points in an image. Setting these points manually affects the overall tonal balance of the image.

**ⓔ Options:** Offers options for automatic image correction.

**ⓕ Auto:** Adjusts the tonal range automatically.

---

| Input Levels and Output Levels | Note>>> |
| --- | --- |

- **Input Levels:** The Input Levels graph or histogram shows 256 shades of gray. The slider on the left is at 0 and represents the darkest pixels in the image, or black. The slider in the middle represents the midtones, and the slider on the right represents the brightest pixels, which are white (at 255).
- **Output Levels:** The Output Levels sliders are used to adjust the overall tonal range. Output Levels affect the image as a whole rather than the individual pixels of the image. Moving the white slider to the left will brighten the image, while moving the black slider to the right makes the image darker.

---

tip >>

| | The Cancel Button |
| --- | --- |

When you hold down the Alt key, the Cancel button changes to a Reset button that can be used to reset an image to its original state.

## Using Shadows to Correct Color

Moving the black slider (on the left in the Levels dialog box) to the right darkens an image while maintaining contrast. This often has the effect of increasing sharpness.

Original image

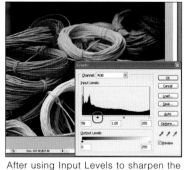

After using Input Levels to sharpen the image

## Using Midtones to Correct Color

The midtones slider adjusts the tones between the dark and bright areas. This can be used to create a more balanced image.

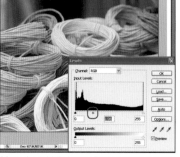

Move the middle input slider towards the left to brighten the midtones.

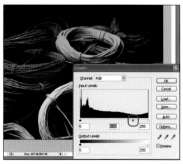

Move the middle input slider toward the right to darken the midtones.

## Using Highlights to Correct Color

Moving the white slider to the left increases brightness while maintaining contrast.

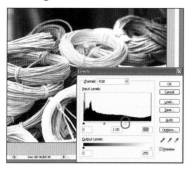

Move the white slider toward the left to expand the highlights.

## Using Individual Color Channels to Correct Color

Changes can be made to a single color channel to correct a specific color within an image.

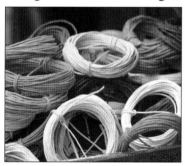

Brightening the midtones in the Red channel

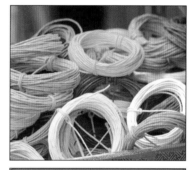

Brightening the midtones in the Green channel

Brightening the midtones in the Blue channel

tip >>

**Auto Corrections**

Photoshop contains a number of auto correction commands:

- **Auto Levels (Shift-Ctrl-L):** Automatically adjusts image tonal levels.
- **Auto Contrast (Alt-Shift-Ctrl-L):** Automatically adjusts image brightness and contrast levels.
- **Auto Color (Shift-Ctrl-B):** Automatically adjusts image color levels.

## The Curves Command

The Curves command (Ctrl-M), like Levels, is used to modify the color and brightness of the image. Curves modifies image using the gamma curve and therefore can be used to do more detailed and meticulous modifying work than Levels. It can modify the entire image, like Levels, or modify respective channel images.

## The Curves Dialog Box

**A Preset:** This is where various Curves values are saved. You can summon and apply the saved Curves values. You can save or summon newly created Curves values.

**B Channel:** Selects the color channel.

**C Edit points to modify the curve / Draw to modify the curve:** The Adjust Curve by Adding Points button allows you to add control points to the curve. The Draw a Curve with the Pencil button enables you to draw a curve by hand.

**D Output:** Displays the new tonal value of the selected point on the curve.

**E Input:** Displays the original tonal value of the selected point on the curve.

**F X Axis:** This axis represents the overall color contrast of the image. The overall color contrast of the image increases as the graph moves left.

**G Y Axis:** This axis represents the overall brightness of the image. The brightness of the image increases as the graph rises higher.

**H Eyedroppers:** Eyedroppers are used to set the black, gray, and white points within the image.

**I Options:** Opens the Auto Color Correction Options dialog box, which lets you decide how color and tones will be corrected.

**J Auto:** Applies the settings entered in the Auto Color Correction Options dialog box.

tip >>

**Displaying an Image Preview**

You should check the Preview option so you can preview the changes you make to your image. If you don't do this, you won't be able to see the changes created by each alteration to the curve shape.

Hold down the Alt key and click the curve to increase the number of grid lines in the graph.

## Curve Differences in CMYK and RGB Modes

If the image mode is set to CMYK by selecting Image > Mode > CMYK Color, the axes for the curve will be reversed from those of an RGB image. The graph for a CMYK image starts with highlights at the bottom-left corner, while the graph for a RGB image starts with the shadows.

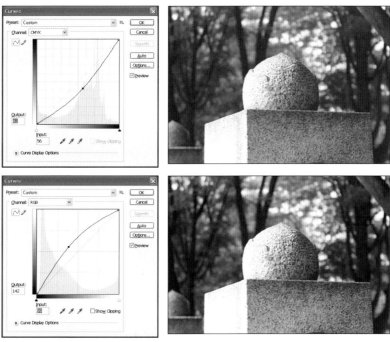

To darken images, make CMYK curves more convex and make RGB curves more concave.

## Using Curves to Sharpen Images

In general, when you change the curve to an S shape as shown in the figure, bright parts become brighter and dark parts become darker, making for a more vivid image on the whole.

Original image                 Changing the curve                 The resulting image is more vivid

# Using Curves to Correct Brightness and Darkness

To change the brightness of an image, modify the Y-axis of the curve, or the output value in general. In RGB mode, when you move the graph higher along the Y-axis in order to make it a convex shape, the output value becomes higher and the overall brightness of the image increases. When you move the graph lower along the Y-axis to make it a concave shape, the output value becomes lower and the overall brightness of the image decreases.

Brightened

Darkened

tip >>

**Creating Custom Curves**

There are two ways to create more complex curves. Click the Edit points to modify the curve with the Pencil button ( ) to draw a curve by hand. Click the Draw to modify the curve button ( ) to add control points to the curve, which you can then move around to change its shape.

## The Color Balance Command

The Color Balance command (Ctrl-B) is used to adjust the balance between complementary colors in an image. You can adjust the color by selecting Shadow, Midtones, or Highlight and dragging the sliders.

# The Color Balance Dialog Box

**Ⓐ Color Balance:** Each of the sliders represents two complementary colors. Adjustments to the sliders add more of one color and subtract the other from an image.

**Ⓑ Color Levels:** You can also adjust the sliders by entering the slider values in the Color Levels fields.

**Ⓒ Tone Balance:** Choose whether you want to make adjustments to the shadows, midtones, or highlights.

**Ⓓ Preserve Luminosity:** The color is adjusted while maintaining luminosity.

tip >>

### Using the Color Balance Command

The Color Balance command cannot be used to adjust large areas of white or black. You have to first adjust the image's luminosity to change these areas to gray before you can add color.

## The Brightness/Contrast Command

The Brightness/Contrast command allows you to adjust the brightness and contrast of an image. Changes made will affect the whole image.

Original image

After adjusting the brightness

## The Brightness/Contrast Dialog Box

**Ⓐ Brightness:** Moving the Brightness slider to the right brightens the image. Moving it to the left darkens the image.

**Ⓑ Contrast:** Moving the Contrast slider to the right increases pixel contrast. Moving it to the left lessens the contrast.

tip >>

### Sharpening an Image

You can sharpen an image by adjusting the Brightness and then changing the Contrast to a setting twice the value of the Brightness setting.

## The Black & White Command

There are many ways to create black and white images with Photoshop. However, by using Photoshop CS3's Black & White, you can create images that have more abundance of black and white. Black & White can adjust the black and white tone for each color of the image, and you can easily make a Duotone image using Tint.

Original image

Image changed into black and white

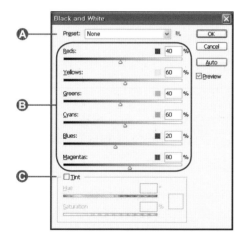

**Ⓐ Preset:** You can use or save a pre-saved black and white value.

**Ⓑ Color adjustment slide:** You can adjust black and white tones according to each color.

**Ⓒ Tint:** You can adjust the Hue/Saturation value and make the image into a Duotone image.

## The Hue/Saturation Command

The Hue/Saturation command (Ctrl-U) is used to adjust an image's color, saturation, and brightness. You can also use the Colorize option in the Hue/Saturation dialog box to create a monotone effect.

Original image

After changing the hue

## The Hue/Saturation Dialog Box

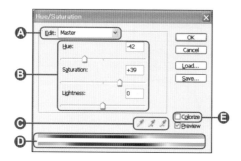

**Ⓐ Edit:** Choose Master to edit the entire image, or select one of the colors to edit only that color.

**Ⓑ Hue/Saturation/Lightness:** The Hue slider changes the color in the image. The Saturation slider determines the amount of color applied; as the slider is moved to the right, colors become richer. As the Lightness slider is moved to the right, the lightness of the color increases.

**Ⓒ Eyedroppers:** The Eyedropper ( ) can be used to select the color that will be modified. The Add to Sample Eyedropper ( ) expands the color area, and the Subtract from Sample Eyedropper ( ) reduces the color area. These tools cannot be used with the Master Edit setting.

**Ⓓ Color bar:** The top color bar represents the color before adjustment. The bottom color bar reflects the corresponding new color. For example, in the images shown above, the pink hues in the image have been replaced by blue hues.

**Ⓔ Colorize:** Colorizes grayscale or black-and-white images.

tip >>

### Creating Black and White Images

There are two ways to create black-and-white images. You can set the Saturation value to –100 in the Hue/Saturation dialog box or use the Desaturate command (Shift-Ctrl-U) to remove color from an image.

## The Match Color Command

The Match Color command applies the color from a source image to another image to alter its color, lighting, and tone. This command is often used to create environmental or artistic effects.

Original file

Source file

Applying the Match Color command

## The Match Color Dialog Box

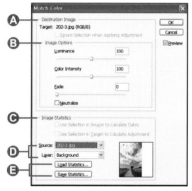

**Ⓐ Destination Image:** The image to be altered by the Match Color effect is indicated here.

*Ignore Selection when Applying Adjustment*: When this option is checked, all selections are ignored and the entire target image is modified by the effect.

**Ⓑ Image Options:** Luminance, Color Intensity, and Fade can be adjusted to alter the final effect. If the target image has a color tint (for example, if the entire image appears reddish), checking the Neutralize box will automatically remove the tint from the image.

**Ⓒ Image Statistics:**

*Use Selection in Source to Calculate Colors*: When this option is checked, the colors are calculated from the source image.

*Use Selection in Target to Calculate Adjustments*: When checked, the colors are calculated from the target image.

**Ⓓ Source/Layer:** Choose the source image or a layer from the source image on which to base the modification of the target image.

**Ⓔ Load Statistics/Save Statistics:** Click Save Statistics to save your settings, or click Load Statistics to load a saved settings file.

## The Replace Color Command

The Replace Color command allows specific colors within an images to be replaced with other colors.

Original image

The color of the stones has been replaced.

## The Replace Color Dialog Box

In the Replace Color dialog box, you can select the color to be changed by clicking the Eyedropper tool (🖋) in the image or Preview window. The Fuzziness setting can be used to expand or reduce the range of colors selected. In the Preview window, white sections represent selected areas and the black sections represent unselected areas. The replacement color can be selected and displayed by adjusting the Hue, Saturation, and Lightness sliders.

ⓐ **Fuzziness:** Use the slider bar to increase or decrease the range of colors selected.

ⓑ **Preview window:** Previews the selection. The selection is shown in white if the Selection option is chosen.

ⓒ **Replacement:** Use to adjust the Hue, Saturation, and Lightness of the selected area.

ⓓ **Result window:** Shows the replacement color.

ⓔ **Eyedroppers:** Use to select color from the image. The Add to Sample Eyedropper (🖋) adds to the selection, and the Subtract from Sample Eyedropper (🖋) reduces the selection.

190

## The Selective Color Command

The Selective Color command allows you to change a specific color by altering the cyan, magenta, yellow, and black composition of the color.

Original image

The amount of magenta in the Red channel has been reduced.

## The Selective Color Dialog Box

Ⓐ **Colors:** Select the color to be modified.

Ⓑ **Method:** The percentage of a CMYK color to be added or subtracted from the selected color can be calculated relatively or as an absolute percentage.

tip >>

**About the Relative and Absolute Methods**

For the sake of this explanation, let's assume that a selected color contains 50% cyan and the Cyan slider is set to 10%. When the method is set to Relative, this means that 10% of 50% cyan (or 5%) will be added, for a total of 55%. When the method is set to Absolute, 10% cyan will be added to 50% cyan, for a total of 60% cyan.

## The Channel Mixer

The Channel Mixer allows you to adjust the red, green, and blue values in an image.

Original image

After increasing the amount of red in the image

## The Channel Mixer Dialog Box

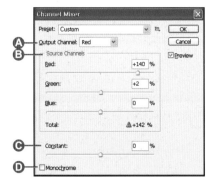

**Ⓐ Output Channel:** Selects the color channel to adjust (red, green, or blue).

**Ⓑ Source Channels:** Adjusts the amount of red, green, and blue in the selected output channel.

**Ⓒ Constant:** Adjusts the contrast for the selected channel.

**Ⓓ Monochrome:** When this option is checked, the image will be changed to grayscale and each channel can be adjusted to create a black-and-white image.

## The Gradient Map Command

The Gradient Map command applies a gradient to an image in relation to the image's original tonal range.

Original image      After applying a yellow-to-blue gradient

## The Gradient Map Dialog Box

**Ⓐ Gradient Used for Grayscale Mapping:** The bar shows the gradient color. Click the triangular button to show the Gradient Picker. When the bar is clicked, the Gradient Editor dialog box will appear.

**Ⓑ Gradient Options:** Dither smoothes out disconnected color. Reverse will apply the gradient mapping in reverse.

tip >>

**Using Gradient Maps**

Images with gradient maps applied look natural when the gradient has darker colors on the left and lighter colors on the right.

## The Photo Filter Command

The Photo Filter command allows you to create effects similar to those achieved by attaching filters to a camera. You can achieve many lighting and environmental effects with this technique.

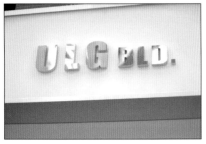

Original image

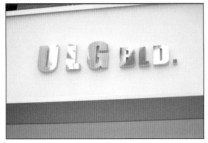

After applying a photo filter

## The Photo Filter Dialog Box

**Ⓐ Filter:** Choose a warming or cooling filter to adjust white balance. To remove a color tint, choose a filter in a complementary color. To create an underwater effect, choose the Underwater filter, which will add a greenish-blue tint.

**Ⓑ Color:** Lets you specify your own color filter.

**Ⓒ Density:** Adjusts the amount of color applied to the image.

**Ⓓ Preserve Luminosity:** Maintains the image's tonal range. If this option is not selected, applying a photo filter can darken an image.

## The Shadow/Highlight Command

The Shadow/Highlight command is used to correct under- or overexposed images while maintaining the overall tonal balance. Click Show More Options to expand the Shadow/Highlight dialog box and adjust the shadows and highlights in greater detail.

Original image

After the Shadow/Highlight adjustment

# The Shadow/Highlight Dialog Box

**Ⓐ Shadows:** Adjusts the dark areas in an image.

*Amount*: To lighten shadows, set a higher Amount value.

*Tonal Width*: To apply the adjustments to more shadows, use a higher tonal width.

*Radius*: The Radius slider determines the number of adjacent pixels that will be used when determining whether a pixel is a shadow. A large radius means that a large group of pixels will be used, applying the adjustments to a larger area.

**Ⓑ Highlights:** Adjusts the bright areas in an image.

*Amount*: To darken highlights, set a higher Amount value.

*Tonal Width*: To apply the adjustments to more highlights, use a higher tonal width.

*Radius*: The Radius slider specifies the number of adjacent pixels that will be used when determining whether a pixel is a highlight. A large radius means that a large group of pixels will be used, applying the adjustments to a larger area.

**Ⓒ Adjustments:**

*Color Correction*: Adjusts the vividness of the colors that have been changed. Increasing the Color Correction value increases vividness.

*Midtone Contrast*: Adjusts contrast in the midtone values.

*Black Clip/White Clip*: Sets the amount of shadow or highlight area that will be set to pure black or white.

**Ⓓ Save As Defaults:** Saves the current settings as the default for future uses of the Shadow/Highlight command.

**Ⓔ Show More Options:** Check to expand the Shadow/Highlight dialog box. (The dialog box is shown in expanded form above.)

## The Exposure Command

Exposure is the amount of light to which film in a camera is exposed. When you use a digital camera, the CCD (Charged Coupled Device) or CMOS (Complementary Metal Oxide Semiconductor Field Transistor) controls the amount of light supplied to an image. The amount of exposure affects the brightness and depth in your images. You can use the Exposure command to adjust these settings.

Original image

Image with modified exposure

## The Exposure Dialog Box

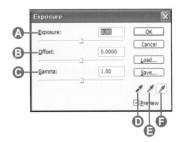

**Ⓐ Exposure:** Adjusts the highlights in an image.

**Ⓑ Offset:** Adjusts the dark tones or shadows in an image.

**Ⓒ Gamma:** Adjusts the midtones in an image.

**Ⓓ Set Black Point:** Adjusts exposure based on a black color point within an image. Click on the image to select the black point.

**Ⓔ Set Gray Point:** Adjusts exposure based on a gray color point. Click on the image to select the gray point.

**Ⓕ Set White Point:** Adjusts exposure based on a white color point. Click on the image to select the white point.

## The Invert Command

The Invert command inverts an image's luminosity so that black areas become white and white areas become black. Colors are inverted to their complementary color.

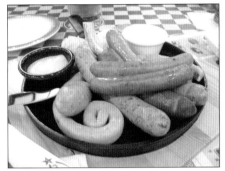
Original image

Inverted image

## The Equalize Command

The Equalize command evens out image tones. It is particularly useful for correcting very dark or bright scanned images. The darkest areas are recognized as black, and the brightest areas are recognized as white. The pixels between (the midtones), are equalized accordingly. Use this command on images with a high contrast.

Original image

Equalized image

## The Threshold Command

The Threshold command turns images into high-contrast, black-and-white images. The luminance value of each pixel is displayed in a histogram. Values higher than 128 (the midpoint) are shown as white, and values lower than 128 are shown as black. The slider can be adjusted to change the midpoint.

Original image

After applying a Threshold Level of 128

### Setting the Threshold Level

Setting the Threshold Level to 128 is the same as setting the Threshold to 50% in the Image > Mode > Bitmap dialog box. Unlike the Threshold dialog box, it is not possible to adjust the midpoint in the Bitmap dialog box.

The Threshold dialog box

## The Posterize Command

The Posterize command simplifies and bands the colors in an image. It can be used to create images with strong colors. Levels set to a value lower than 5 give the most dramatic poster effect.

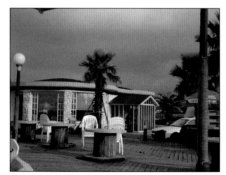

Original image

After setting Levels to 2 in the Posterize dialog box

The Posterize dialog box

## The Variations Command

The Variations command allows you to make color adjustments while comparing the effects of the changes on the image.

Original image

After adjusting the overall image color

## The Variations Dialog Box

The Variations dialog box shows thumbnails with different color variations. The thumbnails on the right show luminosity adjustments. Click a thumbnail to apply the variation. The impact of the correction is altered according to the setting in the Fine/Coarse slider.

Ⓐ **Original:** Shows the original image. When the original image is clicked, all three Current Pick thumbnails will be reset to show the original image.

Ⓑ **Color Adjustment window:** Color is added each time you click a thumbnail.

Ⓒ **Luminosity Adjustment window:** Luminosity is adjusted when either the Lighter or Darker thumbnail is clicked.

Ⓓ **Current Pick:** Shows the adjusted image.

Ⓔ **Fine/Coarse:** Moving the slider bar toward Fine applies small color adjustments, and moving the slider toward Coarse applies larger color adjustments.

*Shadows, Midtones, Highlights, Saturation*: Used to determine where the color adjustments will be made.

Exercise

# 01

# Brightening Part of an Image

It's possible to make color corrections that emphasize only part of an image. We'll explore one approach to this technique in the first exercise.

Final image

Start Files
\Sample\Chapter09\apple.jpg

Final File
\Sample\Chapter09\
apple_completed.jpg

**1** Open the file apple.jpg. The overall image is dark. We'll apply corrections to emphasize the metallic appearance of the apple.

**2** First, we'll create a layer to adjust the curves. Hold down the Alt key, right-click the Add new fill or adjustment layer icon (  ) in the Layers palette, and select Curves.

**3** In the New Layer dialog box, change the Mode to Screen and click OK.

tip >>

### Resource Files

Remember to copy the resource files on the CD-ROM to your hard drive before you start each exercise in this book.

**4** You'll see the Curves dialog box. Change the curve to match the curve shown in the figure above. The overall image becomes brighter.

**5** Click the layer mask thumbnail in the Layers palette and choose Image > Adjustments > Invert. The thumbnail will change to black, as shown in the figure. The image returns to its original state and looks like it did before you made the correction.

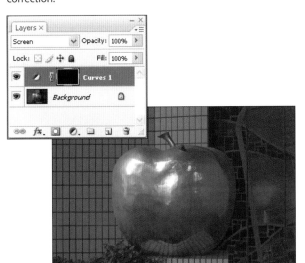

tip >>

### Thumbnail Size

The thumbnail in the Layers palette may appear smaller than you'd prefer.
To enlarge the thumbnail, right-click the ( ✐ ) button and choose Medium or Large from the menu.

**9** Save the file using Save As.

**10** The image is finished.

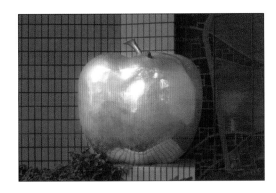

**6** Select the Brush tool ( ✐ ) and adjust the brush size to 8. Set the Opacity to 20%. This will allow you to paint accurately in small areas of the image. Set the foreground color to white.

**7** Enlarge the image and paint over the apple.

**8** When you've finished painting the apple, select the two layers and choose Flatten Image from the palette menu.

tip >>

### Layer Mask Thumbnail

In the Layers palette, you'll see the parts that you've painted in the layer mask thumbnail. You can use this to determine which areas you've painted over.

# 02

# Creating a Unique Duotone Image with Noise Added

Final image

Let's make an original image into a unique Duotone image, simplify the colors, and add a noise filter to the image to make it into a special image.

Start Files
\Sample\Chapter09\telephone.jpg

Final File
\Sample\Chapter09\telephone_end.jpg

**1** Open the telephone.jpg image. To make the image into black and white, choose Image > Mode > Grayscale.

**2** To apply the Duotone, choose Image > Mode > Duotone. Set the Type as Duotone in the dialog box; select Custom Colors, which appears by clicking the Ink2 color; and click OK

**3** To give a sense of depth to the colors of the Duotone, choose Image > Mode > RGB Color. Choose Layer > New Adjustment Layer > Hue/Saturation. Check the Colorize option in the Hue/Saturation dialog box, and set the values of Hue and Saturation as 50 and 40, respectively. Click OK.

**4** Click the Background layer in the Layer palette and choose Filter > Noise > Add Noise. Set the values for Amount and Distribute as 17 and Gaussian, respectively, in the Add Noise dialog box, and select Monochromatic. Click OK to complete the image.

# Changing Some Part of the Black and White Image into a Color Image

Let's add color to some part of the black and white image. There are many ways to create black and white images with Photoshop, but let's first use the Black & White function, which was newly added to Photoshop CS3. The Black & White function enables you to adjust the tone of the black and white image according to each color, and it results in making impressive black and white images.

Start Files

\Sample\Chapter09\flower2.jpg

Final File

\Sample\Chapter09\flower2_end.jpg

Final image

**1** Open the flower2.jpg file. To turn the image into black and white, choose Image > Adjustments > Black & White.

**2** Since most of the black and white images consist of yellow and red parts, enter the values of 133 and 27 for Reds and Yellows, respectively, to emphasize the two color areas, and click OK.

**3** To make color for the part of the image, select the History Brush ( ) tool from the Toolbox. Choose the size of the brush in the option box.

**4** Drag the mouse over the part to be turned into color and create a color image. For detailed work, you can increase the size of the image with the Zoom tool.

tip >>

**Using your keyboard to control Brush size**

You can adjust the size of the brush during work by pressing [, ] on the keyboard.

Final image

Let's create an image with a brush touch using the Brush tool and synthesize it with another image. You can give a unique feeling to each of the synthesized images using different color tones.

Start Files
\Sample\Chapter09\woman01.jpg, woman02.jpg, woman03.jpg

Final File
\Sample\Chapter09\woman_end.psd

**1** Choose File > New, select Preset as Web in the dialog box that appears, set the Size to 640×480, and click OK.

**2** When a new document is created, select the Brush tool from the Toolbox. Open the Brush palette, select Rough Round Bristle as the shape of the brush, and adjust the size of the brush to 55px.

**3** Adjust the size of the Brush tool to 97px, select gray in the Swatches palette, and draw a triangle on the new document. Select black from the Swatches palette, and draw an overlapping triangle.

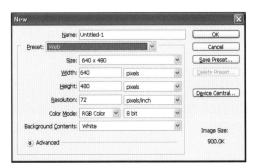

**4** Select the Magic Wand tool from the Toolbox, and click the white area in the triangle image to make it into the selected area. Choose Layer > New > Layer via Copy to make the selected area into a new layer.

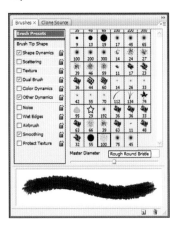

**5** Open the woman01.jpg, woman02.jpg, and woman03.jpg files, and drag all of them over the image with the triangle brush touch with the Move tool from the Toolbox.

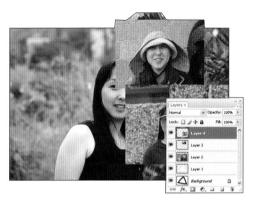

**6** If you click between Layer 1 and 2 in the Layers palette and place the mouse pointer over it while pressing Alt, the Layer 2 image comes into the Layer 1 image. Bring Layers 3 and 4 into Layer 1 as well in the same way.

tip >>

**Applying the Clipping Mask using shortcut keys**

The shortcut function of the Create Clipping Mask enables you to obtain the same results as above by pressing Ctrl-Alt-G.

**7** Select Layer 4 in the Layers palette, and click the Add layer mask button to create the layer mask.

**8** Set the foreground of the Toolbox as black, and select the Brush tool. Adjust the size and shape of the brush, and give a natural touch to the edges of the images overlapped by dragging over the layer mask.

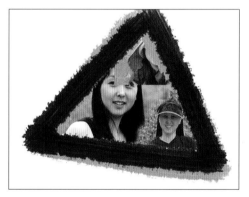

tip >>

**Correcting a Mistake**

If you make a mistake in the process of softening the edges, you can reverse the process by making the foreground white and dragging it over the mistakenly made image.

**9** Make layer masks with the rest of the Layers as well, and soften the edges of the image to complete the image.

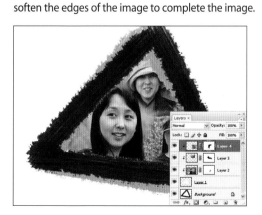

**Chapter** | **10**

Filters

Photographers attach filters to their camera lenses to create special effects in their photos. Photoshop provides numerous filters for recreating these effects in your images. In addition, there are filters that alter your graphics in ways that aren't possible outside the digital realm, such as adding textures, altering lighting, and creating dramatic artistic effects. You can also purchase additional filters from third-party software companies that expand the possibilities even further. This chapter covers the filters included in Photoshop CS3.

# 01

# The Filter Menu

Filters, more than any other feature of photoshop, will allow you to wildly change the look of your images. From subtle and tasteful to overblown and tacky, you can pretty much do it all from the Filter menu. In this section, we'll walk you through all your options to acquaint you with the possibilities. Just remember, a little goes a long way!

## The Convert to Smart Filter

The smart filter is a function that can readjust and apply the filter value if the value applied is wrong. In the previous version, you had to return to the previous stage using the History function or apply the filter again from the beginning to modify the applied filter value. Now, however, you can readjust an applied filter value by applying the filter after setting the smart filter. In particular, when two or more filters are applied, the application order can also be changed. Moreover, the image before the application of the filter can be easily confirmed, and you can apply various filters.

## The Extract Command

The Extract command (Alt-Ctrl-X) extracts part of an image to leave a transparent background. Choose Filter > Extract and the Extract dialog box appears as shown below.

Use the Edge Highlighter tool to draw around the area to extract and fill the area with the Fill tool. When you're happy with the selection, click OK to extract the image. The background will be removed.

**Ⓐ Edge Highlighter tool ( ,B):** Use this tool to draw around the area to extract.

**Ⓑ Fill tool ( , G):** Use this tool to fill the area to extract. You cannot use this tool when Force Foreground is checked.

**Ⓒ Eraser tool ( ,E):** Removes an area painted with the Edge Highlighter or Fill tool.

**Ⓓ Eyedropper tool ( ,I):** You can use this tool when Force Foreground is checked to determine the color to be extracted. Select colors from the area painted by the Edge Highlighter tool.

**Ⓔ Cleanup tool ( ,C ):** Removes artifacts left behind when you preview the extraction.

**Ⓕ Edge Touchup tool ( ,T):** Drag this tool around previewed edges to make them more clearly defined.

**Ⓖ Zoom tool ( ,Z):** Use this tool to zoom in or out of an image.

**Ⓗ Hand tool ( ,H):** Use this tool to move the view in the preview window.

**Ⓘ Tool Options:**
*Brush Size:* Sets the size of the brush.
*Highlight:* Choose a color for the Edge Highlighter tool.
*Fill:* Choose a color for the Fill tool.
*Smart Highlighting:* Check this option to detect and highlight the area automatically.

Tool Options

### Ⓙ Extractions:

Extractions

*Textured Image:* Choose this option if the image is textured.

*Smooth:* Determines how to smooth the edges of the extracted image.

*Channel:* Separates the image using channels.

*Force Foreground:* Check this option if you want to use the Eyedropper tool to select the color to extract from the area painted by the Edge Highlight tool. You can't use the Fill tool when you select this option.

*Color:* Shows the color selected by the Eyedropper tool.

### Ⓚ Preview:

*Show:* Shows a preview of the extracted area or selects the original image.

*Display:* Sets the display of the separated image and background.

*Show Highlight:* Shows the area painted with the Edge Highlight tool.

*Show Fill:* Shows the area painted with the Fill tool.

Preview

## The Filter Gallery

The Filter Gallery contains the filters that you can apply to your images. Filters are grouped into categories along with thumbnails showings the filters' effects.

Ⓐ Shows a list of filters. Click a filter name to apply it to an image.

Ⓑ Select a filter and change the filter options.

Ⓒ You can apply multiple filters at the same time or delete existing filters. Click the eye icon to turn a filter on or off. Click the New effect layer button to add a new filter. Select a filter and remove it by clicking the Delete effect layer button.

## The Liquify Command

The Liquify command (Shift-Ctrl-X) distorts the pixels in an image and allows you to warp, twirl, expand, contract, or reflect the image by dragging. Click the Show Mesh option to display a grid over the image. This allows you to see how the image has been distorted.

Ⓐ **Forward Warp tool ( ,W):** Drag with this tool to warp pixels.

Ⓑ **Reconstruct tool ( ,R):** Restores the image to its original state.

Ⓒ **Twirl Clockwise tool ( ,C):** Click or drag to twirl the image clockwise. Hold down the Alt key to twirl the image counterclockwise.

Ⓓ **Pucker tool ( ,S):** Click or drag to pucker the pixels toward the center of the brush.

Ⓔ **Bloat tool ( ,B):** Click or drag to bloat the pixels and expand the image.

Ⓕ **Push Left tool ( ,O):** Moves pixels to the left when you drag the tool straight up (pixels move to the right if you drag down).

Ⓖ **Mirror tool ( ,M):** Use the mouse to create a reflection axis for the image.

Ⓗ **Turbulence tool ( ,T):** Click or drag to create waves.

Ⓘ **Freeze Mask tool ( ,F):** Paint areas to prevent changes. They will appear red.

Ⓙ **Thaw Mask tool ( ,D):** Unfreezes frozen areas.

Ⓚ **Hand tool ( ,H):** Moves the view in the preview window.

Ⓛ **Zoom tool ( ,Z):** Zooms in or out of the image.

### ⓜ Tool Options

*Brush Size:* Sets the size of the brush.

*Brush Density:* Sets the density of the brush.

*Brush Pressure:* Sets the pressure for the brush. Used for tablet peripherals.

*Brush Rate:* Sets the rate of distortion when the tool is stationary.

*Turbulent Jitter:* Determines how the Turbulence tool changes pixels.

*Reconstruct Mode:* Restores the image using the Reconstruct Mode options. This mode is only available when the Reconstruct tool is selected.

*Stylus Pressure:* Check this option to use stylus pressure when applying changes.

Tool Options

### ⓝ Reconstruction Options

*Mode:* Choose from Revert (image is fully restored), Rigid (distortion is extended), Stiff (distortion lessens as you move farther from the boundary), Smooth (smoothes distortion), and Loose (distortion becomes more continuous).

*Reconstruct:* Restores the image in steps each time you click.

*Restore All*: Fully restores the image.

Recoustruct Options

### ⓞ Mask Options

*None:* Removes the mask from the image.

*Mask All:* Masks all areas of the image.

*Invert All:* Inverts masked and unmasked areas of the image.

Mask Options

① Choose Replace selection to replace the masked area with the selected selection, transparency, or layer mask.

② Add to Selection displays the mask in the original image and allows you to add to the mask using the Freeze tool.

③ The Subtract from Selection option subtracts from the selection.

④ Choose Intersect with Selection to add only intersecting areas to the mask.

⑤ The Invert Selection option converts everything outside of the selection into a mask. It excludes the currently masked areas.

### ⓟ View Options

*Show Image/Show Mesh:* Shows the image and/or mesh.

*Show Mask:* Shows or hides the mask.

*Mask Color:* Sets the color for the mask. The default color is red.

*Show Backdrop:* Displays the original image in the background as you edit.

View Options

## The Pattern Maker Command

The Pattern Maker command (Alt-Shift-Ctrl-X) allows you to create patterns from a selection or from the clipboard. You can use horizontal and vertical offsets to create criss-cross patterns.

**Ⓐ Rectangular Marquee tool ( , M):** Creates a rectangular selection.

**Ⓑ Zoom tool ( , Z):** Zooms in or out of the image.

**Ⓒ Hand tool ( , H):** Moves the view in the preview window.

**Ⓓ Tile Generation:**

*Use Clipboard as Sample:* Generate a pattern from the selection copied to the clipboard.

*Use Image Size:* Click to enter the current image size.

*Weight, Height, Offset, Amount:* Sets the pattern's width and height, as well as the direction and overlap in the patterns.

*Smoothness:* A higher setting makes tile edges less obvious.

*Sample Detail:* Determines the amount of detail from the original image that will be preserved in the pattern.

Tile Generation

**Ⓔ Preview:**

*Show:* Shows the original or generated pattern images.

*Tile Boundaries:* Check to see the tile pattern edges.

Preview

**Ⓕ Tile History:**

*Update Pattern Preview:* Check to view a previous pattern state.

: Saves or removes the tile history.

Tile History

## The Vanishing Point

It allows you to adjust the perspective in an image.

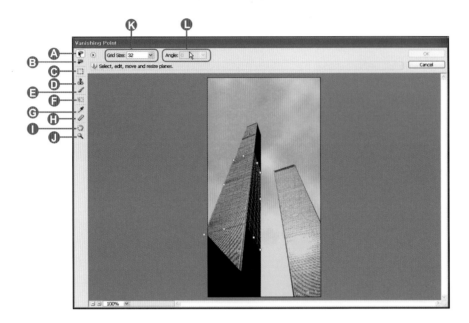

**A** **Edit Plane tool ( ,V):** Moves, edits, or resizes planes within the image.

**B** **Create Plane tool ( ,C):** Creates grid planes in the image.

**C** **Marquee tool ( ,M):** Makes a selection.

**D** **Stamp tool ( ,S):** Copies part of an image to another location using the grid perspective.

**E** **Brush tool ( ,B):** Paint color.

**F** **Transform tool ( ,T):** Rotates, resizes, or reverses grids.

**G** **Eyedropper tool ( ,I):** Selects a color.

**H** **Measure tool( ,R):** Calculate distance and angle within planes.

**I** **Hand tool ( ,H):** Moves the view inside the preview window.

**J** **Zoom tool ( ,Z):** Zooms in or out of the image.

**K** **Grid Size:** Sets the grid size within planes.

**L** **Angle:** Sets the incidence angle.

## The Standard Filters

The standard filters in Photoshop allow you to apply visual effects to images. Some filters are not available in certain color modes. For example, the Artistic filters can't be used in CMYK mode or Lab mode. You may need to change the color mode to RGB before applying these filters.

## The Artistic Filters

There are 15 Artistic filters that apply artistic effects to an image.

Original image

## Colored Pencil

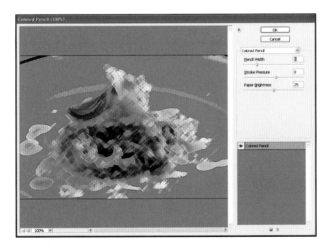

The Colored Pencil filter makes an image look as if it were drawn with colored pencils. Edges are given a crosshatch appearance and the background color shows through the pencil strokes.

- **Pencil Width**: Changes the pencil stroke thickness.
- **Stroke Pressure:** Changes the intensity of the pencil strokes.
- **Paper Brightness:** Modifies the brightness of the paper underneath.

## Cutout

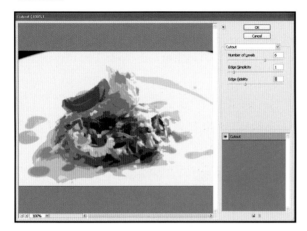

The Cutout filter makes an image look as if it were made from cut-out pieces of paper.

- **Number of Levels:** Determines the number of layers of colored paper. Smaller numbers create simpler images.
- **Edge Simplicity:** Simplifies edges. Larger values create simpler edges.
- **Edge Fidelity:** Sets the image edge precision. Larger values create edges that are more detailed.

## Dry Brush

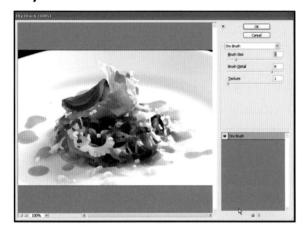

The Dry Brush filter paints the edges with a dry brush effect.

- **Brush Size:** The smaller the brush size, the more detailed the image.
- **Brush Detail:** The higher the Brush Detail value, the more detailed the image.
- **Texture:** The higher the value, the rougher the texture of the image.

## Film Grain

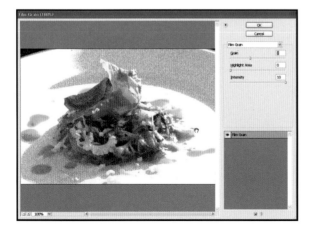

The Film Grain filter adds noise or small dots to an image.

- **Grain:** Sets the size of the noise. Larger values display more dots.
- **Highlight Area:** The higher the value, the more highlights there will be in the image.
- **Intensity:** A smaller number adds dots to the entire image. Larger values add dots only to darker parts of the image.

## Fresco

The Fresco filter imitates the fresco painting style from the Renaissance. It paints an image with short dabs, creating a darker image than the original.

- **Brush Size:** Sets the size of the brush. The smaller the size, the more detailed the image.
- **Brush Detail:** Higher Brush Detail values create images that are more detailed.
- **Texture:** Higher Texture values create rougher textures in the image.

## Neon Glow

The Neon Glow filter adds glow effects to an image. The filter uses the foreground color from the Toolbox as well as the color in the Neon Glow dialog box. To apply this filter to a text layer, you need to choose Layer > Rasterize first.

- **Glow Size:** A large Glow Size value colors the highlights with the glow color and the shadows with the foreground color. Small values work in the opposite way.
- **Glow Brightness:** When this is set to 0, the image is filled with the foreground color. Larger values create highlights using the glow color.
- **Glow Color:** Sets the highlight color for the image.

## Paint Daubs

The Paint Daubs filter creates an oil painting effect.

- **Brush Size:** Smaller brushes create more detail in the image.
- **Sharpness:** Increasing the Sharpness creates more defined edges.
- **Brush Type:** Choose from Simple, Light Rough, Dark Rough, Wide Sharp, Wide Blurry, and Sparkle brushes.

## Palette Knife

The Palette Knife filter creates the effect of a palette knife being used on the image.

- **Stroke Size:** The higher the value, the more colors bunch together in the image.
- **Stroke Detail:** The higher the value, the more detailed the resulting image.
- **Softness:** Alters the degree of smearing in the image.

## Plastic Wrap

The Plastic Wrap filter creates the appearance that the image has been wrapped in transparent plastic.

- **Highlight Strength:** Determines the shine of the plastic.
- **Detail:** Changes the detail of the texture created by the plastic.
- **Smoothness:** Sets the smoothness of the plastic.

## Poster Edges

The Poster Edges filter reduces the colors in the image and creates dark edges.

- **Edge Thickness:** Determines thickness of the dark edges.
- **Edge Intensity:** Changes the number of dark edges.
- **Posterization:** A low value creates a high contrast image, while a high value creates an image with more tones.

## Rough Pastels

The Rough Pastels filter gives the image the appearance of colored pastel chalks on a textured background.

- **Stroke Length:** Higher values create more obvious chalk strokes.
- **Stroke Detail:** Higher values increase the contrast and color in an image.
- **Texture:** Choose from Brick, Burlap, Canvas, and Sandstone textures. The Load Texture feature allows you to load a saved *.PSD file containing a texture.
- **Scaling:** Changes the size of the texture.
- **Relief:** Larger values create more depth in the texture, making it seem more embossed.
- **Light:** Set the direction of the light.
- **Invert:** Inverts the texture.

## Smudge Stick

The Smudge Stick filter creates the appearance that the image was smeared before the paint dried.

- **Stroke Length:** Higher values increase the amount of smudging in the image.
- **Highlight Area:** Changes the amount of highlights in the image.
- **Intensity:** Higher values brighten the image and remove details from the highlights.

## Sponge

The Sponge filter makes the image look as if it was sponged.

- **Brush Size:** Sets the size of the sponge.
- **Definition:** Sets the contrast.
- **Smoothness:** Larger values increase thesponging effect.

## Underpainting

The Underpainting filter makes the image appear to have been painted on a textured background, giving it a softer focus.

- **Brush Size:** The smaller the brush size, the more detailed the image.
- **Texture Coverage:** Smaller values apply the texture to darker parts of the image. Larger values apply the texture to the whole image.
- **Texture:** Choose from Brick, Burlap, Canvas, and Sandstone. The Load Texture feature allows you to load a saved ∗.PSD file containing a texture.

## Watercolor

The Watercolor filter creates a watercolor painting effect.

- **Brush Detail:** Higher values create a more detailed and smoother image.
- **Show Intensity:** Darkens the image.
- **Texture:** Higher values create less smooth images.

# The Blur Filters

The Blur filters are used to blur an image or a selection. This can be useful to remove noise from a scanned image.

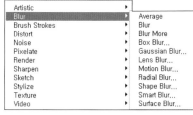

## Average

This filter takes an average color from the image or selection and fills using that color.

## Blur

The Blur filter smoothes an image. There are no options for this filter, so you'll often apply it several times to achieve the final effect.

## Blur More

The Blur More filter provides a stronger blur effect than that of the Blur filter.

## Box Blur

The Box Blur filter blurs the image taking into account the average color value of the surrounding pixels.

- **Radius:** Defines the amount of blur applied to images.

## Gaussian Blur

The Gaussian Blur filter allows you to specify the intensity of the blur effect. It is useful for creating smudge, shadow, or haze effects.

- **Radius:** Defines the amount of blur applied to images.

## Lens Blur

The Lens Blur filter adds a depth-of-field effect so that some objects stay in focus while others become blurred. Unlike other Blur filters, you can use the Lens Blur filter to apply different amounts of blur to each section without making selections.

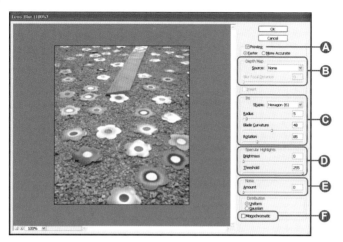

**Ⓐ Preview:** Check Preview to preview the blur effect. Because the effect is memory intensive, you can choose between Faster and More Accurate.

**Ⓑ Depth Map:** This option determines the depth-of-field in the image.

*Source:* Select an area to blur within the image. None blurs the whole image, Transparency blurs the transparent area, Layer Mask blurs the layer mask, and Alpha Channel blurs the alpha channel.
*Blur Focal Distance:* Sets the point in the image that will be in focus.
*Invert:* Inverts the focused and blurred sections of the image.

**Ⓒ Iris:** Sets the properties of the camera iris attribute to change the way the blur appears. The effect is very subtle and you'll need to zoom into the image to see the differences between each setting.
*Shape:* Determines the iris shape.
*Radius:* Determines the intensity of the blur.
*Blade Curvature:* Determines the roundness of the iris.
*Rotation:* Sets the amount of iris rotation.

**Ⓓ Specular Highlights:** According to Adobe, these options change the highlights in an image. From our own experiments, these options appear to have no effect on images. The effect is subtle, to say the least.

*Brightness:* Increases the brightness of the highlights.
*Threshold:* Pixels brighter than the threshold are changed to highlights.

**Ⓔ Noise:** Adds noise to the image.

*Amount:* Determines the amount of noise to add.
*Distribution:* Choose from a Uniform or Gaussian (random) noise distribution.

**Ⓕ Monochromatic:** Sets noise to grayscale.

## Motion Blur

The Motion Blur filter blurs an image in a single direction to give the effect of movement. It produces a similar effect to taking a picture of an object moving faster than the camera's shutter speed.

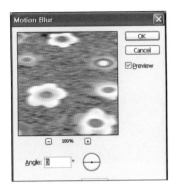
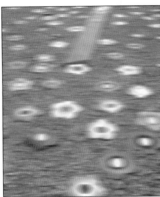

- **Angle:** Sets the angle of motion.
- **Distance:** Set the distance of the blur effect.

## Radial Blur

The Radial Blur filter creates a blur around a center point for a zoom or rotation effect.

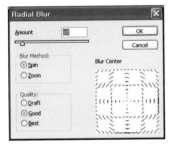
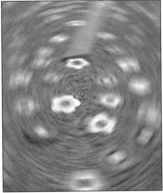

- **Amount:** Determines the areas to which the effect will apply with respect to the center.
- **Spin:** Creates the blur by spinning the image.
- **Zoom:** Creates the effect of a camera zooming in or out of the image.
- **Draft:** Creates a rough texture.
- **Good:** Creates an average level of detail.
- **Best:** The final image is detailed but the effect takes a while to apply.
- **Blur Center:** Sets the center of the blur effect. Click or drag to specify this point.

## Shape Blur

The Shape Blur filter produces a blur effect in a defined shape.

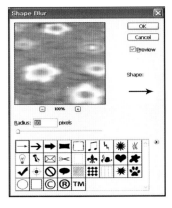 

- **Shape:** Choose a shape for the blur effect.
- **Radius:** Determines the intensity of the blur.

## Smart Blur

The Smart Blur filter applies a blur while maintaining the overall contours of the image.

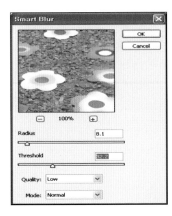 

- **Radius:** Determines the area for the blur.
- **Threshold:** Determines the threshold for the blur effect. For pictures of people, use high Threshold values to create an even skin tone.
- **Quality:** Changes the quality of the effect.
- **Mode:** Choose from Normal, Edge Only (displays edges in black and white), and Overlay Edge (displays edges in white)

## Surface Blur

The Surface Blur filter blurs the image while leaving clear boundaries.

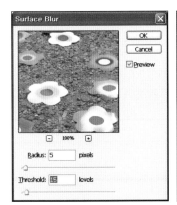 

- **Radius:** Determines the amount of blur.
- **Threshold:** Adjusts the bright and dark parts of the image boundaries.

# The Brush Strokes Filters

The Brush Stroke filters create images with brush stroke textures.

## Accented Edges

The Accented Edges filter creates strong edges in the image.

- **Edge Width:** Sets the edge thickness.
- **Edge Brightness:** A low value creates dark edges, while higher values create light edges.
- **Smoothness:** Sets the smoothness of the brush the strokes.

## Angled Strokes

The Angled Strokes filter creates an image with diagonal brush strokes. Light-colored strokes go in the opposite direction from dark colored strokes.

- **Direction Balance:** Alters the number of lines going in the two directions.
- **Stroke Length:** Sets the length of the strokes.
- **Sharpness:** Sets the sharpness of the strokes.

## Crosshatch

The Crosshatch filter creates an image that looks like it was drawn in crosshatch pencil lines.

- **Stroke Length:** Sets the length of the strokes.
- **Sharpness:** Sets the sharpness of the strokes.
- **Strength:** Higher values increase the number of strokes.

## Dark Strokes

The Dark Strokes filter uses short, black strokes in darker parts of the image, and long, white strokes in brighter areas.

- **Balance:** A small value adds strokes to brighter areas, while large values add strokes to the darker areas of the image.
- **Black Intensity:** Darkens the shadows in the image.
- **White Intensity:** Brightens the highlights in the image.

## Ink Outlines

The Ink Outlines filter creates image edges that look as if they were drawn in ink.

- **Stroke Length:** The length of the strokes.
- **Dark Intensity:** Darkens the image.
- **Light Intensity:** Lightens the image.

## Spatter

The Spatter filter creates an image that looks like it was sprayed with an airbrush.

- **Spray Radius:** Determines the resolution of the spray effect. The larger the value, the more scattered the edges are.
- **Smoothness:** Sets the smoothness in the image.

## Sprayed Strokes

The Sprayed Strokes filter uses angled, sprayed strokes to create a rough-looking image.

- **Stroke Length:** The length of the strokes.
- **Spray Radius:** Determines the resolution of the spray effect. The larger the value, the more scattered the edges.
- **Stroke Direction:** Sets the direction of the spray.

## Sumi-e

The Sumi-e filter makes the image appear as if it were painted in black ink on rice paper using a wet brush.

- **Stroke Width:** Sets the width of the stroke.
- **Stroke Pressure:** Sets the pressure of the stroke.
- **Contrast:** Sets the contrast of the image.

# The Distort Filters

Distort filters change the shape of an image. They can also produce 3D effects. These filters are memoryintensive, so it is advisable to reduce the size and resolution of large images before applying these filters.

## Diffuse Glow

The Diffuse Glow filter adds white noise to an image. Applying this filter to an image on a white background creates a foggy effect.

- **Graininess:** Sets the grain size.
- **Glow Amount:** Determines the amount of glow.
- **Clear Amount:** Calculates the areas where the fog effect is applied. Larger values add grains only to bright areas while smaller values add grains to the whole image.

## Displace

The Displace filter uses a displacement map from a *.PSD file to determine how to distort an image.

- **Horizontal Scale:** Sets the degree of horizontal distortion.
- **Vertical Scale:** Sets the degree of vertical distortion.
- **Displacement Map:** Determines how the original image will be displayed on the displacement map.

  *Stretch to Fit:* Adjusts the size of the map source image to the size of the original image.

  *Tile:* Uses the map source at its original size and tiles the map to fill the original image.

- **Undefined Areas:** Determines how empty space is treated.

  *Wrap Around:* Fills empty spaces with a selection from the opposite side of the image.

  *Repeat Edge Pixels:* Fills empty spaces with a repeating pattern of edge pixels.

## Glass

The Glass filter creates the effect of a pane of glass in front of the image.

- **Distortion:** Modifies the refraction in the glass.
- **Smoothness:** Sets the smoothness of the refraction.
- **Texture:** Offers Blocks, Canvas, Frosted, and Tiny Lens textures.
- **Scaling:** Sets the size of the texture.
- **Invert:** Inverts the applied texture.

## Lens Correction

The Lens Correction filter corrects deficiencies in an image arising from the camera lens.

- **Remove Distortion tool:** Applies a distortion filter to the image grid.
- **Straighten tool:** Click the image grid to insert a new horizon line. The image will be corrected according to this line.
- **Move Grid tool:** Moves the image grid.
- **Hand tool:** Moves the view in the previewm window.
- **Zoom tool:** Zooms in and out of the image.
- **Settings:** Applies previous settings to the current image or creates new user-defined settings.

## Ocean Ripple

The Ocean Ripple filter adds ripples to make an image look as if it is underwater.

- **Ripple Size:** Sets the size of the ripples.
- **Ripple Magnitude:** Defines the area covered by the ripples.

## Pinch

The Pinch filter pinches or squeezes an image.wet brush.

- **Amount:** A positive value creates a concave lens effect, and a negative value creates a convex lens effect.

## Polar Coordinates

The Polar Coordinates filter either creates a polar shape from an image or reverses the process.

- **Rectangular to Polar:** Creates an effect similar to holding one side of the image and stretching it in a circle so that both sides of the image meet up.

- **Polar to Rectangular:** Reverses the Rectangular to Polar effect.window.

## Ripple

The Ripple filter adds waves or ripples to the image.

- **Amount:** Changes the number of ripples.

- **Size:** Choose from Small, Medium, or Large ripples.

## Shear

The Shear filter distorts the image along a curve.

- **Wrap Around:** Fills empty spaces by repeating the image.

- **Repeat Edge Pixels:** Fills empty spaces by repeating edge pixels.

## Spherize

The Spherize filter creates a 3D effect by wrapping the image around a sphere from the camera lens.

- **Amount:** A positive value creates a concave lens effect, while a negative value creates a convex effect.
- **Mode:** Choose from Normal (fisheye lens effect), Horizontal only (stretches the image horizontally), and Vertical only (stretches the image vertically). window.

## Twirl

The Twirl filter twirls the image around its center point.

- **Angle:** A positive value twirls the image clockwise, while a negative value twirls it counterclockwise.

## Wave

The Wave filter adds waves to an image.

- **Number of Generators:** Sets the number of waves.
- **Wavelength:** Sets the length of the waves.
- **Amplitude:** Sets the height of the waves.
- **Scale:** Sets the amount of distortion.
- **Type:** Determines the type of wave. Choose Sine for a normal wave, Triangle for a pointed wave, or Square for small squares within the wave.
- **Randomize:** Generates random waves.
- **Wrap Around:** Fills empty spaces by repeating the image.
- **Repeat Edge Pixels:** Fills empty spaces using a repeating pattern of edge pixels.

## ZigZag

The ZigZag filter creates concentric ripples on the surface of an image reverses the process.

- **Amount:** Determines the direction of the ripple's spin.
- **Ridges:** Sets the number of concentric circles.
- **Style:** Choose from Around Center to create a whirlpool effect, Out from Center to create ripples moving from the outside to the inside, or Pond Ripples to create the kind of ripples you see after throwing a stone into water.

# The Noise Filters

The Noise filters either create noise or remove it from an image.

## Add Noise

The Add Noise filter adds random pixels of varied color and brightness to the image.

- **Amount:** Sets the overall amount of noise.
- **Uniform:** The generation and distribution of noise are influenced by the Amount.
- **Gaussian:** Random noise is generated by Gaussian distribution.
- **Monochromatic:** Grayscale noise is generated.

## Despeckle

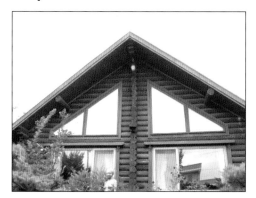

The Despeckle filter removes noise from an image without affecting the detail within the image.

## Dust & Scratches

The Dust & Scratches filter removes noise and dust from images by changing dissimilar pixels.

- **Radius:** Larger values blur the image more.
- **Threshold:** Determines how large different pixels must be before they are removed. A lower value removes more pixels and increases the blur in the image.

## Median

The Median filter blends the brightness of pixels to remove noise, creating a watercolor effect.

- **Radius:** Determines the area to be averaged. Larger values create blurrier images.

## Reduce Noise

The Reduce Noise filter removes random noise that appears on images from digital cameras.

- **Settings:** Choose a setting from the list.
- **Strength:** Sets the strength of the filter.
- **Preserve Details:** Sets the proportion of details to preserve.
- **Reduce Color Noise:** Sets the proportion of color in the noise to reduce to gray.
- **Sharpen Details:** Determines how much to sharpen the image.
- **Remove JPEG Artifact:** Check to remove artifacts created by a JPEG file that uses a high compression rate.

## The Pixelate Filters

The Pixelate filters group pixels together to create effects.

## Color Halftone

The Color Halftone filter creates the effect of viewing a printed image at high magnification. The colors in the image are represented by dots. CMYK images use four colors.the detail within the image.

- **Max. Radius:** Sets the size of the halftone dots.
- **Screen Angles (Degrees):** Sets the angle of the halftone dots for each channel.

## Crystallize

The Crystallize filter creates polygonal pixels of uniform color within the image to produce a crystalline appearance.

- **Cell Size:** Sets the size of the polygons.

## Facet

The Facet filter groups pixels of similar color to create a painted effect. watercolor effect.

## Fragment

The Fragment filter creates vibrating or unfocused images by making four copies of the image and offsetting them from each other.

## Mezzotint

The Mezzotint filter distorts an image using black dots, lines, or strokes.

- **Type:** Select a Mezzotint pattern.

## Mosaic

The Mosaic filter groups adjacent pixels into square blocks.

- **Cell Size:** Sets the size of the squares.

## Pointillize

The Pointillize filter breaks an image into randomly placed dots, as in the works of painters such as George Seurat. The background swatch in the Toolbox becomes the background color.

- **Cell Size:** Sets the size of the dots.

# The Render Filters

The Render filters create rendered effects like 3D shapes, clouds, and lighting effects.

 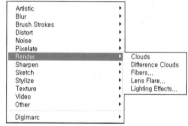

## Clouds

The Clouds filter generates a cloud pattern using the foreground and background swatches in the Toolbox. Hold down the Alt key to create clouds with greater contrast.

## Difference Clouds

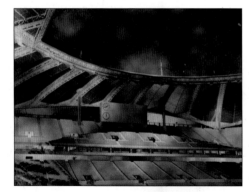

The Difference Clouds filter produces clouds from the foreground and background colors and blends them using the Difference blend mode.

## Fibers

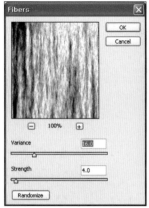

The Fibers filter creates a fiber texture using the foreground and background colors from the Toolbox.

- **Variance:** Sets the variance in the texture. Lower values create smoother images with long fibers.
- **Strength:** Increasing the strength stretches fibers vertically and makes the fibers more distinct.
- **Randomize:** Click to create a random fiber pattern.

## Lens Flare

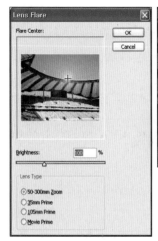

The Lens Flare filter simulates the effect of light reflecting off a camera lens.

- **Brightness:** Sets the brightness of the lens flare.
- **Flare Center:** Click on the image to set the position of the flare.
- **Lens Type:** Sets the lens type.

# Lighting Effects

The Lighting Effects filter lets you add artificial lighting effects. You can adjust the placement, color, brightness, and intensity of the lights.

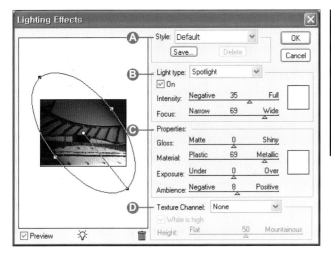

**Ⓐ Style:** Provides preset lighting styles. You can also create user-defined styles.

**Ⓑ Light Type**

*Directional:* Creates a light that shines from far away in a single direction, like sunlight.

*Omni:* Creates a light that shines directly above the image, like an incandescent light.

*Spotlight:* Creates a light that shines at an angle, creating an elliptical beam of light.

*Intensity:* Sets intensity of the light. Negative values dim the light.

*Focus:* Sets the spread of light and is only available with the Spotlight.

**Ⓒ Properties:** Sets the properties of other factors that will affect the lighting.

*Gloss:* Determines how much light is reflected by the image. Toward Matte, highlights disappear, whereas choosing Shiny reflects more light.

*Material:* Choose between Plastic and Metallic. Plastic reflects the color of the light, whereas Metallic reflects the color of the object.

*Exposure:* Sets the exposure of the light. Values toward Under reduce the light.

*Ambience:* Determines the amount of light from other sources. As you move toward Negative, the image gets darker because ambient light is removed.

**Ⓓ Texture Channel:** Uses a channel to create texture in the image.

*White is high:* By default, the darker the pixels in the channel, the higher the texture relief in the final image. Checking this option reverses the setting.

*Height:* Changes the depth of the texture details. The 3D effects are weaker when you choose values closer to Flat.

# The Sharpen Filters

The Sharpen filters focus and sharpen blurred images. This makes images more vivid by increasing the color contrast of pixels.

## Sharpen

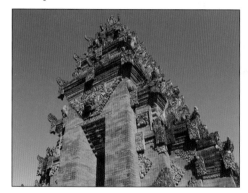

The Sharpen filter increases the color and hue contrast to sharpen the image. This is the same as the Sharpen tool in the Toolbox.

## Sharpen Edges

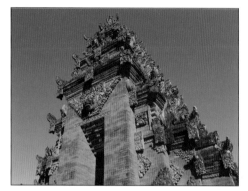

The Sharpen Edges filter sharpens edges where they contain changes in color.

## Sharpen More

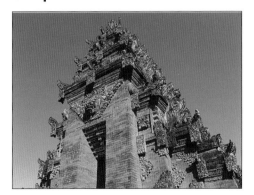

The Sharpen More filter is the equivalent of applying the Sharpen filter twice.

## Smart Sharpen

The Smart Sharpen filter finds edges and reduces sharpening halos.

## Unsharp Mask

The Unsharp Mask filter allows you to control the sharpness settings.

- **Amount:** Sets the degree of the sharpening effect.
- **Radius:** Determines the intensity of the edges in the sharpened image. Greater values create a more obvious effect.
- **Threshold:** Sets the degree to which pixels must differ from surrounding pixels before they are treated as edge pixels and sharpened.

# The Sketch Filters

The Sketch filters add texture to images.

## Bas Relief

The Bas Relief filter gives a carved-stone effect to an image.

- **Detail:** Sets the detail of the texture.
- **Smoothness:** Sets the smoothness of protruding areas.
- **Light:** Sets the direction of the light source.

## Chalk & Charcoal

The Chalk & Charcoal filter creates an image that looks like it was drawn with chalk and charcoal. The background color is used for highlights and is drawn with chalk. The foreground color is used for shadows and is drawn with charcoal.

- **Charcoal Area:** Sets the area of the charcoal effect.
- **Chalk Area:** Sets the area of the chalk effect.
- **Stroke Pressure:** Higher values apply more chalk and charcoal to the image.

## Charcoal

The Charcoal filter draws an image in charcoal using the foreground color.

- **Charcoal Thickness:** Sets the thickness of the charcoal.
- **Detail:** Sets the detail in the charcoal strokes.
- **Light/Dark Balance:** The smaller the value, the less charcoal is used.

## Chrome

The Chrome filter changes the image to grayscale and creates a metallic surface.

- **Detail:** Sets the detail of the Chrome effect.
- **Smoothness:** Sets the smoothness of the surface.

## Conté Crayon

The Conte Crayon filter uses the foreground color for the dark parts of an image, and the background color for bright parts. The image looks as if it was drawn with crayon on textured paper.

- **Foreground Level:** Adjusts the amount and coverage of the foreground color.
- **Background Level:** Adjusts the amount and coverage of the background color.
- **Texture:** Choose from Brick, Burlap, Canvas, and Sandstone. The Load Texture feature allows you to load a saved *.PSD file containing a texture.
- **Light:** Set the direction of the light source.
- **Invert:** Inverts the angle of the light source.

- **Scaling:** Set the size of the texture.
- **Relief:** Set the depth of the texture's surface.

245

## Graphic Pen

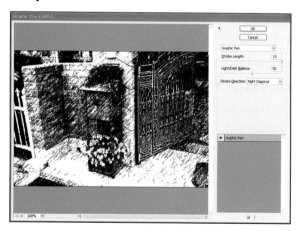

The Graphic Pen filter uses ink strokes to create an image that looks as if it were drawn with a fine pen.

- **Stroke Length:** Set the length of the pen lines.
- **Light/Dark Balance:** A low value intensifies the light areas, while a high value intensifies the dark areas.
- **Stroke Direction:** Sets the direction of the pen strokes.

## Halftone Pattern

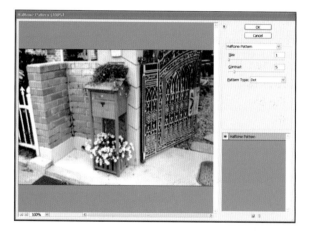

The Halftone Pattern filter turns an image into halftone shapes such as dots, lines, and concentric circles. The foreground color is used for the shapes, the background color is used for the paper.

- **Size:** Sets the size of the shapes.
- **Contrast:** Sets the contrast within the image.
- **Pattern Type:** Set the shape as Circle, Dot, or Line.

## Note Paper

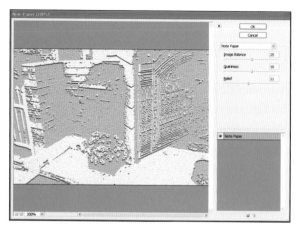

The Note Paper filter adds an embossing effect to an image.

- **Image Balance:** Larger values create more dark areas within the image.
- **Graininess:** Adjusts the texture of the paper.
- **Relief:** Sets the depth of the texture.

## Photocopy

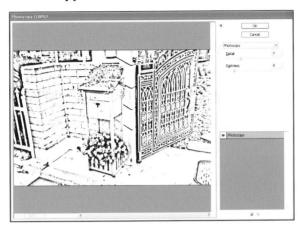

The Photocopy filter creates an image that looks like a photocopy.

- **Detail:** Sets the level of detail in the image.
- **Darkness:** Sets the overall image darkness

## Plaster

The Plaster filter produces 3D effects similar to those achieved when using a plaster mold.

- **Image Balance:** Moving the slider to the left reduces the depth of the effect and increases use of the background color. Move the slider to the right for the opposite effect.
- **Smoothness:** Determines the smoothness of the image.
- **Light:** Sets the position of the light source.

## Reticulation

Creates an image that appears clumped in the shadows and lightly grained in the highlights by simulating the controlled shrinking and distortion of film emulsion.

- **Density:** Determines the intensity of the effect.
- **Foreground Level:** Sets the amount of foreground color used.
- **Background Level:** Sets the amount of background color used.

## Stamp

The Stamp filter produces the effect of printing with a rubber stamp using the foreground color on paper of the background color.

- **Light/Dark Balance:** Decreasing the value increases the foreground color areas, while increasing the value enlarges the background color areas.
- **Smoothness:** Determines the smoothness of the image.

## Torn Edges

The Torn Edges filter is similar to the Stamp filter, but expresses the edges as torn pieces.

- **Image Balance:** Decreasing the value increases the foreground color areas, while increasing the value enlarges the background color areas.
- **Smoothness:** Determines the smoothness of the image.
- **Contrast:** Sets the degree of contrast.

## Water Paper

The Water Paper filter creates an image that looks like it was drawn on wet paper.

- **Fiber Length:** A high value creates a blurry image, while lower values increase the amount of detail.
- **Brightness:** Sets the brightness of colors in the final image. The default value is 50.
- **Contrast:** Sets the contrast of colors in the final image. The default value is 50.

# The Stylize Filters

The Stylize filters create a painted or impressionistic effect. You can use these tools to create outline, embossing, and projection effects.

## Diffuse

The Diffuse filter shuffles pixels to make the image appear less focused.

- **Normal:** Diffuses all pixels in the image.
- **Darken Only:** Diffuses only the dark pixels in the image.
- **Lighten Only:** Diffuses only the light pixels in the image.
- **Anisotropic:** Softens the overall image.

## Emboss

The Emboss filter fills the image with gray and creates a 3D look using embossing and carving.

- **Angle:** Determines the angle of the light source.
- **Height:** Sets the height of the embossing.
- **Amount:** Determines the severity of the effect.

## Extrude

The Extrude filter paints the image over 3D blocks or pyramids.

- **Type:** Choose from Blocks or Pyramids.
- **Size:** Sets the size of the blocks or pyramids.
- **Depth:** Sets the degree of extrusion. Random sets the depth randomly, while Level-based extrudes brighter areas more than darker areas.
- **Solid Front Faces:** For blocks, each block is a solid color.
- **Mask Incomplete Blocks:** When unchecked, blocks cover the entire image and broken blocks are used for edges. When checked, edge areas are left blank, forming a border.

## Find Edges

The Find Edges filter creates outlines around the edges in the image against a white background.

## Glowing Edges

The Glowing Edges filter is similar to Find Edges but creates neon outlines against a black background.

- **Edge Width:** Modifies the thickness of edge lines.
- **Edge Brightness:** Sets the brightness of the edges.
- **Smoothness:** Sets the smoothness of the edges.

## Solarize

The Solarize filter blends the negative of the image with the original. It produces a similar effect to exposing film to light.

## Tiles

The Tiles filter breaks the image into tiles.against a white background.

- **Number Of Tiles:** Sets the number of tiles.
- **Maximum Offset:** Sets the spacing between tiles.
- **Fill Empty Area With:** Choose how to fill empty spaces. Use the Background color, Foreground color, Inverse Image (fills with the inverse color of the image), or Unaltered Image (fills with the original image).

## Trace Contour

Like the Find Edges filter, the Trace Contour filter creates lines, but using a brighter color. Remaining areas are filled with white.

- **Level:** Sets the tonal threshold to determine which areas should be outlined.
- **Edge:** Determines whether the details of the image must be above (Upper) or below (Lower) the Level value to be outlined.

# Wind

The Wind filter creates a windswept effect.

- **Method:** Determines the force of the wind. Choose from Wind, Blast, and Stagger.

- **Direction:** Sets the direction of the wind: left or right.

# The Texture Filters

Texture filters add texture to images.

# Craquelure

The Craquelure filter adds fine cracks to an image so it looks like it is painted on a plaster surface. You can expect better results with high contrast images.

- **Crack Spacing:** Sets the spacing of the cracks.
- **Crack Depth:** Sets the depth of the cracks.
- **Crack Brightness:** Sets the brightness of the cracks.

## Grain

The Grain filter adds dots, lines, or small particles to an image.

- **Intensity:** Adjusts the number of grains in the image.
- **Contrast:** Sets the image contrast.
- **Grain Type:** Choose from Regular (small dots), Soft (soft, small dots), Sprinkles (small dots using the background color), Clumped (clumped dots), Contrasty (high-contrast dots), Enlarged (enlarged dots), Stippled (sprayed in foreground and background colors), Horizontal (black horizontal lines), Vertical (black vertical lines), and Speckle (speckled dots).

## Mosaic Tiles

The Mosaic Tiles filter creates a texture with cracks in a mosaic pattern.

- **Tile Size:** Sets the tile size.
- **Grout Width:** Sets the spacing between tiles.
- **Lighten Grout:** Sets the brightness of the space between tiles.

## Patchwork

The Patchwork filter breaks the image into small squares.

- **Square Size:** Sets the size of the squares.
- **Relief:** Sets the thickness of the squares.

## Stained Glass

The Stained Glass filter creates a stained-glass effect. The foreground color is used for the edges.

- **Cell Size:** Sets the size of the cells.
- **Border Thickness:** Sets the thickness of cell borders.
- **Light Intensity:** Sets the brightness of the light shining through the stained glass.

## Texturizer

The Texturizer filter adds a variety of textures to an image.

- **Texture:** Choose from Brick, Burlap, Canvas, and Sandstone. The Load Texture feature allows you to load a saved *.PSD file containing a texture.
- **Scaling:** Sets the size of the texture.
- **Relief:** Sets the strength of the texture.
- **Light:** Sets the direction of the light source.
- **Invert:** Inverts the surface texture.

## The Video Filters

The Video filters correct problems in images captured from TV or video.

## De-Interlace

The De-Interlace filter removes the scan lines that appear in images captured from TV or video.

- **Eliminate:** Select the scan lines to eliminate: Odd Fields (removes odd scan lines) or Even Fields (removes even scan lines).
- **Create New Fields by:** Select a method to fill the deleted scan lines. Duplication will copy from the image, while Interpolation will fill with midtones.

## NTSC Colors

The NTSC Colors filter converts the colors in an image to the NTSC color system used by televisions.

## The Other Filters

Other filters include Custom, High Pass, Maximum, Minimum, and Offset.

## Custom

The Custom filter lets you create your own filter effects using matrix calculations. This is a difficult filter to use and it can create unexpected results.

## High Pass

The High Pass filter retains edge details with high contrast and fills remaining areas with midtones.calculations. This is a difficult filter to use and it can create unexpected results.

- **Radius:** The higher this value, the more intense the final effect.

## Maximum

The Maximum filter spreads out highlights and shrinks shadows in the image.

- **Radius:** Increasing the Radius expands the highlights.

## Minimum

The Minimum filter expands the dark areas in the image and shrinks the white areas.

- **Radius:** Increasing the radius expands the shadows.

## Offset

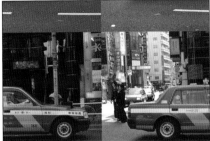

The Offset filter moves the image horizontally or vertically.

- **Horizontal:** Sets the distance for horizontal movement.

- **Vertical:** Sets the distance for vertical movement.

- **Undefined Areas:** Determines how empty spaces are filled. Choose from Set to Background (uses the background color), Repeat Edge Pixels (fills with a repeating pattern of edge pixels), and Wrap Around (fills with the corresponding section from the other side of the image).

# The Digimarc Filter

The Digimarc filter prevents illegal use of digital images. When copyrighted images are opened in Photoshop, the © appears in front of the title.

## Embed Watermark

Click Personalize to add your Digimarc ID. The Personalize Digimarc ID dialog box appears and you can enter your Digimarc ID. Visit the Digimarc Web site (www.digimarc.com) to buy a Digimarc ID.

## Read Watermark

Shows the copyright information for the image.

# Making an Image Look as if it were Drawn with Colored Pencils

Let's make an image look as if it were drawn with colored pencils using the filters of Photoshop.

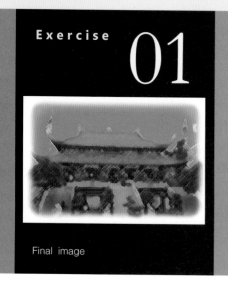

Final image

Start Files

\Sample\Chapter10\temple.jpg

Final File

\Sample\Chapter10\temple_end.jpg

**1** Open the temple.jpg file. Drag Background with the Create a new layer button in the palette to create the Background copy layer.

**2** Choose Filter > Convert for Smart Filters to make the copied Background copy layer into a smart filter.

**3** Set the foreground and background colors as 'black' and 'white' respectively. Choose Texture > Grain, and set Intensity to 18, Contrast to 50, and Grain Type to Sprinkles in the dialog box.

**4** Click New effect layer in the filter dialog box, and choose Artistic > Colored Pencil. Enter values of 4, 8, and 25 as Pencil Width, Stroke Pressure, and Brightness, respectively, and click OK.

**5** Select the Square Selection tool from the Toolbox. Drag the outskirts as shown in the picture to make it into a selected area.

**6** Click Refine Edge in the option bar to open the dialog box, set the value as shown in the picture, and click OK.

**7** Choose Select > Inverse to reverse the selected area. Choose Layer > Rasterize > Layer to change the Smart Filter Layer into a normal layer.

**8** Press Ctrl-Delete to fill the background color in the image. Exit the selection mode by pressing Ctrl-D. The background should be white.

# Maintaining Perspective While Modifying an Image

In this exercise, we will add windows to a building while maintaining perspective using the Vanishing Point tool.

Final image

Start Files
\Sample\Chapter10\window.jpg

Final File
\Sample\Chapter10\window_completed.jpg

**1** Open the file \Chapter10\window.jpg in Photoshop.

**2** Choose Filter > Vanishing Point from the menu.

**3** Zoom into the image with the Zoom tool ( 🔍 ).

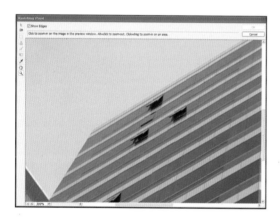

**5** Select the Marquee tool ( ⬚ ). Use it to make a selection as shown in the figure.

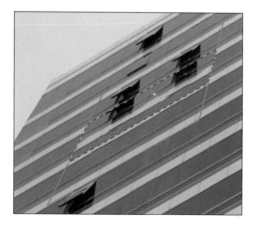

**4** Select the windows to copy as shown here using the Create Plane tool ( ⊞ ). Set the tool options as shown at the bottom of the window. Set Heal to Off so that the copied image looks similar to the selected open window.

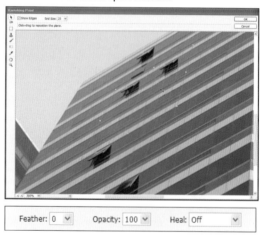

**6** Point at the middle of the selection, hold down the Ctrl key, and drag the selection as shown in steps 6 and 7.

**7** Release the selection in an appropriate position, as shown in the figure.

**8** Now we'll copy another floor of windows. Hold down the Alt key and drag the windows downward, as shown.

**9** Clear the selection using Ctrl-D and click OK.

# Extracting Part of an Image Using the Extract Filter

In this exercise, we will extract the roof from the image using the Extract filter.

Final image

Start Files
\Sample\Chapter10\toy.jpg

Final File
\Sample\Chapter10\toy_end.jpg

**1** Open toy.jpg in Photoshop.

**2** Choose Filter > Extract from the Menu bar.

tip >>

### Correcting Edge-Highlight Errors

If you make a mistake with the Edge Highlight tool, hold down the Alt key. The brush changes to the Eraser tool so you can erase the error.

**3** We'll need to select the area of the image to extract. Use the Edge Highlight tool ( ) to paint around the edge of the roof as shown.

**4** Fill the selected area using the Fill tool ( ).

tip >>

### Hand-Tool Shortcut

You can access the Hand tool by holding down the spacebar. This allows you to move the view in the image window.

**5** Click the Preview button to preview the extracted image. To clarify the selection, change the display to Gray Matte in the Preview options. If the perimeter of the image is not precise, you can modify the selection using the Cleanup tool ( ).

**6** Click OK to complete the extraction.

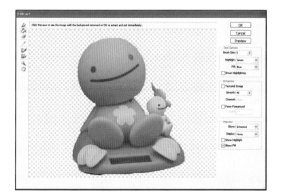

**7** The background has been removed and only the selected portion of the image is visible.

# Index > > >